Arctic Dreams and Nightmares

Alootook Ipellie

Theytus Books Ltd.
Penticton, B.C. Canada

Canadian Cataloguing in Publication Data

Ipellie, Alootook, 1951-
Arctic dreams and nightmares

ISBN: 0-919441-47-5

1. Inuit--Canada--Fiction* I. Title.
PS8567.P44A8 1993 C813'.54 C93-091740-5
PR9199.3.I64A8 1993

The publisher acknowledges the support of the Canada Council and the Cultural Ser-
vices Branch of the Province of British Columbia in the publication of this book.

Production and Design: Banjo and Greg Young-Ing
Cover Design: Greg Young-Ing and Banjo

Published by

THEYTUS BOOKS LTD.
P.O. Box 20040
Penticton, B.C. Canada
V2A 8K3

Dedication

For my daughter Taina Lee and to the memory my parents,

Napatchie and Joanassie

Acknowledgements

I would like to thank a number of people who made it possible for me to work on the drawings on a full-time basis. First and foremost is Richard McNeely who encouraged and supported me from the outset of this project. Jens Lyberth and Rasmus Lyberth of Greenland believed in my art and allowed me to continue. Also the Explorations Program of the Canada Council gave me a grant to complete the rest of the drawings and the stories in this book.

Thank you, Joyce MacPhee, for your editorial help.

And to the courage of my ancestors, the bravery of our elders and the promise in our youth. Inuutsiaritsi.

Alootook Ipellie
Ottawa, Ontario
May 1993

Table of Contents

Introduction

I was born in a hunting camp on the shores of Baffin Island in Canada's eastern Arctic. Until I was about four years old, in 1955, our family led a semi-nomadic lifestyle, living off the renewable resources of the land. I was often in awe of the extraordinary abilities of my elders to understand the seasons, in knowing the behaviour of all the Arctic animal species, and to co-exist with their fellow Inuit in a common goal to survive as a collective. In the Arctic's harsh environment, one mistake or a lapse in judgement could spell certain disaster. By observing, listening to and practising what my elders did, I was instilled with the will to survive for the moment and go on for another day. Being a young man exposed to such a mentality, I learned to be thirsty for life. Today, this same thirst is firmly placed in my heart and mind.

I spent most of my adolescence in Iqaluit, formerly called Frobisher Bay in southern Baffin Island, during a period of Inuit cultural upheaval - from its infancy to its full force. It was a trying period for most families like ours, struggling to adjust to community living that brought with it new social problems, mainly created by alcohol abuse.

It took me ten years to reach Grade 7 and I was sent away by the Federal Government to Southern Canada to receive higher education, which wasn't available in our community in 1967.

I learned some skills allright, but, in the end, I eventually became a cultural cast-off. Like many of my peers, I would never again pursue my traditional culture and heritage as an Inummarik, a real Inuk. Once embedded in a southern environment, I was trained largely to cope with the white, Anglo-Saxon, Euro-Canadian culture. Being young and naïve, I listened intently to my white guardians in Ottawa. My fear of academic failure made me determined to succeed in my studies. I never had any idea what higher education would bring me.

My Department of Indian and Northern Affairs guidance counsellors worked hard to channel me into a practical trade. I could very easily have become a mechanic, perhaps an office clerk, or a heavy-equipment operator. These were some of the top career choices suggested to me at the time. Instead, I chose art, a subject which my trusty counsellors frowned upon. It was their opinion that this subject was "impractical" to work with in the Arctic. But that really inspired me to prove I had some artistic talent I wanted to pursue. The logical step was to work hard to make true believers of them so they wouldn't prematurely end my training.

I enrolled in a four-year Vocational Arts Course when I entered high school. However, two years into the course, I lost interest due to the rigours of school life, and became fed up with living in a large city. I was also homesick for my community and the beautiful Inuit I had grown up with. In due time, I was allowed to go back to Iqaluit.

But when I re-settled back in my hometown, I wasn't able to find employment. It was an easy decision to take upgrading at the Adult Education Centre and take another try at completing high school. I soon found out that I wasn't able to concentrate on my studies and decided to quit school for good. Everything I did after that seemed pointed towards a life of oblivion. Sure enough, I became a drifter who had turned his back on a wonderful opportunity to become a part of the art world. On reflection, I realized I was facing a dead-end road, and I didn't understand why I had quit the Vocational Arts Course, since I was so keen to enter it as a young man.

The creative drive I possessed early in my art training revived my creative juices once in a while. One day, I remembered what my art teachers in the Vocational Arts Course had said: "Practice makes perfect." If I still had a faint hope of becoming an artist of note, that's exactly what I had to do - practice to perfection.

When I was a child, my elders taught me that patience was a human virtue. A prerequisite to acquiring the skills of a successful hunter was the ability to wait perfectly still, in dead silence, for long periods of time. On a vast land like the Arctic, sound carries easily for long distances. In order to get my first seal from its breathing hole on the sea ice, I had to possess a heart of steel and the determination to wait for as long as it took for the seal to come to me. I learned early in life that it wasn't easy to fool an animal that lived in its own environment and to practise its own game as a predator.

I have now plied my trade as an artist and writer for close to twenty years. I am reminded of the first time I ever sold my art - seven ink drawings at three dollars each. I have never forgotten the wonderful feeling I experienced knowing I had twenty-one dollars in my pocket - all at the same time! The person who bought those drawings was a small-business entrepreneur in our community. He told me that day he was going to send my work to an art gallery in Montreal. After all these years, I sometimes wonder where those drawings ended up. Are they hanging proudly on the walls of some rich family's home in Montreal? Or, were they long ago discarded as unworthy of anyone's walls? I tend to believe the latter to be true. My sense of pride and dignity has never allowed me to ask the small- business entrepreneur exactly where the drawings ended up. My reasoning is, he did pay cold, hard cash. So, I suppose he bought the right to decide what to do with them.

As a young artist, I used to find it unbelievable to be able to sell a product of my creative mind and artistic talent. I've since figured it's the people's uninspired dispositions that make them willing to part with their hard-earned dollars and purchase a by-product of someone else's imagination. For this reason, I consider myself as providing a useful service to mankind. I am really an entertainer who entertains those who are unable to entertain themselves. To this end, I am a privileged artist.

I haven't forgotten about being someone with a fabled past. For the better part of my adult life, I have been trying to figure out the meaning of life. I am not the only person who faces this ultimate question on a daily basis. We just have to acknowledge the number of professionals who make a very good living trying to make us believe that our lives do have some meaning other than the obvious physical presence it has on this planet. I admit to tinkering with this possibility lest I lose out on what could turn out to be an immortal glimmer of hope that our lives really do have meaning.

There is only one thing I am absolutely sure about: that I was bluntly dropped on this planet by my parents without being asked. I am quite certain they were very happy to have me, but, since my mother had no access to birth control, which is available in the Arctic today, I will never find out whether or not I was accidently conceived.

I consider myself fortunate that my artistic and creative nature takes over the course of most of my days. I believe what I produce is my way of contributing to humanity's quest for the meaning of life. This is why I feel the need to do the very best I can when I produce a piece of art or when I write. Since the dawn of human habitation on this planet, people of all stripes have tried for a lifetime to find their minds, without success, myself included. This is why I believe the search for the meaning of life is really the parallel search to understand the ever-elusive human mind. I have therefore decided the wise thing to do is to simply concentrate on the creative nature of my mind.

It so happens that the mind needs to be continually entertained or preoccupied in order to survive the mundane world we were so unceremoniously born into. This is where artists of diverse disciplines come happily to the rescue, be they good or bad, considered grandmasters in their particular field or those who will forever remain obscure. We humans have to wonder how this world may have turned out if it weren't blessed with the creativity of its artists.

Looking back to recent Inuit history, I used to question the presence of the so-called 'Arctic administrators' who were regularly sent to northern communities to provide authority over the lives of Inuit. Having once been subjected to some of their determined efforts to recreate us as human beings much like themselves, I have often wondered how much longer they intend to play 'god' in our lives. These administrators were looked upon by our ancestors as demigods in times of hardship and starvation on the land. These are the same people who, over time, gradually took away the ability of the majority of Inuit to survive on this same land by forcing them to settle in communities where they could no longer practise their traditional pursuits. When Inuit became helplessly trapped in the midst of their cultural upheaval, the administrators went out of their way to provide the goods and services to rescue them. Thereby this guaranteed the administrators the dubious honour of becoming 'saviours' of Inuit. Understandably, Inuit would flock around the administrators asking for assistance in the manner of orphaned children.

Another pertinent question soon surfaced. What was to be done with a people who were, by nature, semi-nomadic, when they began to live collectively in all seasons instead of travelling from camp to camp in search of wild game? The administrators had a ready answer to the Inuit predicament: cultural assimilation, which could later lead to cultural genocide. All the other indigenous peoples around the world found themselves in the same predicament. What the Arctic administrators had in their hands was the well-worn blueprint that was proving to be successful beyond their wildest dreams.

Right until the 1940s, the Canadian Arctic was still considered one of the last frontiers in an increasingly shrinking world. It was the last bastion of a distinctive culture, largely untouched by any civilized nation, including Canada. Even though the land and its harsh climate seemed unwelcoming to outsiders; the predicament of hardship caused by famine and disease made it much easier for the assimilators to use their perceived magical solutions to win the trust of Inuit. The catalyst for the administrators, who wanted to convert a nomadic people to manageable collectives, was the natural friendliness of Inuit to other peoples. With one giant, index finger, the assimilators went about enticing the psyche of the downtrodden Inuit in the manner of professional prostitutes: "You can see the goods. Now, come and get them. Your culture in payment for mine."

There is an oft-told story of how a certain Arctic administrator magically transformed the natural artistic talents of the Inuit into what is today a multi-million dollar Inuit Art industry.

The now-famous Inuit Co-operative movement in the Canadian Arctic encouraged Inuit to produce arts and crafts to supplement their incomes. A select number of Inuit have become either expert carvers, printmakers, embroiderers, weavers or painters. A few are now world-renowned in their particular disciplines of art. In this imperfect world, according to the response to their work, they have succeeded beyond their wildest dreams and expectations. One feels proud of these Inuit artists who have the skill and the creative imagination to take advantage of other people's search for a unique piece of art unlike any found in a competitive art world.

When I write, I try to do my part to make this world and other people's lives a little more bearable. I write essentially about the Arctic and its people, the Inuit - the semi-nomads who were made to settle down, for better or for worse. I must admit it hasn't been easy interpreting the trials and tribulations of my people. It has been a relief to write about the occasional triumph. I write about what I think is right in translating the failures and accomplishments of a distinct culture caught in an unpredictable cultural transition.

Today, the traditional culture and heritage are largely memories to most Inuit. This is especially so for our elders who practised it incognito for much of their lives. Young Inuit are trying their best to imagine how and what it was like in those heady days when the natural world ruled their ancestors' lives.

The challenge for all Inuit today is in trying to retain what they can about all aspects of their once-rich, traditional culture and heritage. They've ridden a bumpy road travelling from virtually a stone-age era to the twentieth century within a very short span of time. The ability of Inuit to adapt to change has served them well during a time of great cultural upheaval. It wasn't so long ago that some staunch pessimists dismissed Inuit as being on the brink of extinction, like so many animal species that may disappear from the face of the Earth.

However, a resilient culture can roll with all the well-placed punches and survive intact. It is the will and the perpetual pride of our elders that has helped us to retain the old myths, stories and legends so that our present generation can absorb them and pass them on to future generations. Inuit have been more fortunate than other aboriginal groups in retaining much of their culture and language, because they live in the remote Arctic, relatively isolated from the rest of the world.

The constant threat of cultural genocide continues to hang over their collective lives today, as it will for successive generations to come. Since economic, social, and political pressures from the outside cannot be suppressed forever, it will become increasingly harder to keep their culture and language intact. This threat is doubly scary with only a handful of Inuit, estimated at around one hundred thousand, living in the world. Perhaps all they can do is cocoon themselves the best way they know how from other cultures during this crucial era. They have already suffered many setbacks, only to spring back even more determined to go on, despite the unrelenting odds hounding them, seemingly non-stop, from every direction.

Inuit are living in an age when they are being taught new tools to help them deal with the modern world. Aside from the political and economic tools, they still need to deal with various Arctic problems; the tools of Inuit artists are being used quite successfully in forging the positive aspects of their culture. It's an indication of the vibrant imagination of a people when great pieces of art are being produced year-in and year-out.

One may ask why such a large percentage of the Inuit population in Arctic Canada is so artistically inclined. Inuit are a people with a traditional culture that relied solely on skillful hands in fashioning all their hunting gear and the clothing needed to survive fierce winters. Another answer to the question may lie in their ability to adapt their imagination and their story-telling tradition to suit today's artistic demands. These

talents, which were once used strictly for means of survival, have been successfully adapted to modern conditions and artistic purposes.

Recognition for any artist, whether they be Inuit or non-Inuit, doesn't come easily. Artists receive accolades from the masses through the integrity of their work. It has never been the sole preoccupation of Inuit artists to seek recognition. It has always been the outsiders who have bestowed accolades whether or not the artists were look-ing for them. This is how a great artist gains recognition from the masses, whether or not the artist is still alive. That is how it should be. Have you ever heard of an artist who bought fame, through monetary means, or through a well-conceived gimmick? Some, of course, have tried throughout history, with little or no success.

Some years ago, I approached some of the so-called stewards of 'Inuit Art' to find out if they were interested in representing my work. Some of these stewards were appoin-tees to the Eskimo Arts Council, which was a ruling body created by the Canadian Government to oversee and ultimately, to dictate which pieces of Inuit Art should be seen and put up for sale to the outside world. I also did my bit to interest employees of the Inuit Art Section of the Department of Indian and Northern Affairs for the same purpose. Both of these exercises were to help me find my bearings within the so-called 'Inuit Art World' since I was an Inuk who happened to be an artist. Previous to that, I

had often wondered whether or not these stewards would designate my work as a worthy part of the 'monster' they had created.

Their initial reaction to my work was obvious. Disinterest, at best. In the end, this made me ill tempered. Why was I a victim of their faint murmurs as they looked at my work? Was my work not easy to categorize and, therefore, not fit the mold they had steadfastly built and helped protect on behalf of my fellow Inuit artists? These were the only conclusions I came to. However, a curious thing happened each time I went to see them. These stewards never volunteered to comment or hint with the few words of criticism I wanted for my own benefit. Instead, they stickhandled their way out of my reach with carefully selected phrases like: "Perhaps this or that person, or this or that gallery will advise you or show interest in exhibiting your work."

In the end, I would gather my drawings into my well-travelled portfolio and silently leave the premises with this recurring thought: "Ahhh, I can still see a faint light at the end of the tunnel." It was my personal good fortune that these futile encounters never came close to devastating my sense of dignity and pride in my work. What they did do, was to help pump up my resolve - "back to the drawing board" - to continue pro-ducing the kind of art I love: line drawings in black and white.

I've been doing line drawings for the past twenty-five years, primarily as an illustrator for Inuit magazines, newspapers, and newsletters. I have also illustrated books and various articles, and created original cartoons based on Inuit politics, aspirations, and struggles against assimilation of my people and the more-fearsome genocidal tides created by the technologically superior culture of the Anglo-Saxon, Euro-Canadians.

In some ways, I think I am fortunate to have been part and parcel of an era when cultural change pointed its ugly head to so many Inuit who eventually became victims of this transitional change. It is to our credit that, as a distinct culture, we have kept our eyes and intuition on both sides of the cultural tide, aspiring, as always, to win the battle as well as the war. Today, we are still mired in the battle, but the war is finally ending.

Initially, this book evolved by chance. What I originally had in mind was to complete fifty line drawings and then find a gallery willing to take a chance with my work. However, as each piece was completed, and the collection grew larger, I became enthralled with the idea of writing stories based on some of the drawings. The stories came to me quite naturally every time I became immersed in creating each piece. So, I revised my original idea and the main focus of the project eventually became to connect each drawing with a story. I think, in the back of my mind, I had always wanted to do such a book. This goes back to the time, as a young man, I began getting serious about

my art and my writing. The irony is, I was so inexperienced and utterly without confidence in my artistic or writing talent. But my true ally was the ability to dream, as I still do today.

Some of the stories the drawings inspired are true in a sense they happened in my dreams and nightmares. Other stories were inspired by people and events surrounding my daily life. Still other stories and drawings came to me inspired by my ancestors' extraordinary gift for inventing myths, stories, and legends. So, this book has become, quite by accident, a smorgasbord of stories and events, modern or traditional, true or imagined.

This is a story of an Inuk who has been dead for a thousand years and who then recalls the events of his former life through the eyes of his living soul. It's also a story about a powerful shaman who learned his shamanic trade as an ordinary Inuk. He was determined to overcome his personal weaknesses, first by dealing with his own mind and, then, with the forces out of his reach or control.

The Arctic is a world unto its own where events are imagined yet real and true to life, as we experience them unfolding each day.

I hope the reader and observer will enjoy this particular journey as much as I did experiencing it in person and in the imagination of my soul.

Alootook Ipellie

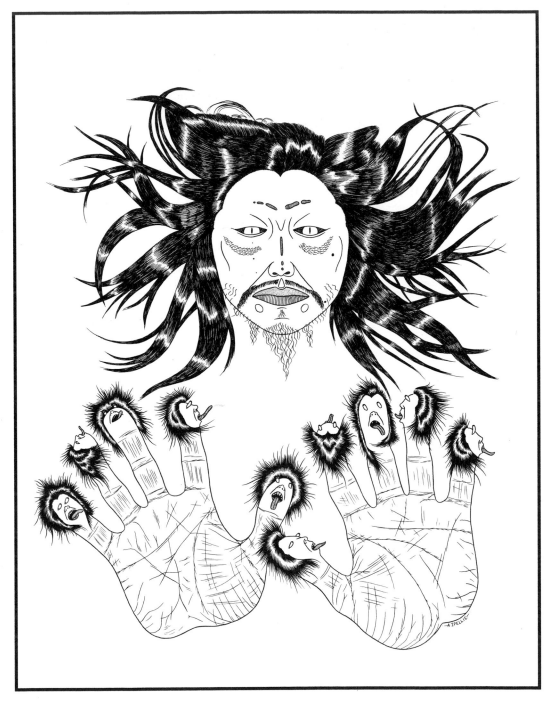

Self-Portrait: Inverse Ten Commandments

I woke up snuggled in the warmth of a caribou skin-blanket during a vicious storm. The wind was howling like a mad dog, whistling whenever it hit a chink on my igloo. I was exhausted from a long, hard day of sledding with my dogteam on one of the roughest terrains I had yet encountered on this particular trip.

I tried going back to sleep, but the wind kept waking me as it got stronger and ever louder. I resigned myself to just laying there in the moonless night, eyes open, looking into the dense darkness. I felt as if I was inside a black hole somewhere in the universe. It didn't seem to make any difference whether my eyes were opened or closed.

The pitch darkness and the whistling wind began playing games with my equilibrium. I seemed to be going in and out of consciousness, not knowing whether I was still wide awake or had gone back to sleep. I also felt weightless, as if I had been sucked in by a whirlwind vortex.

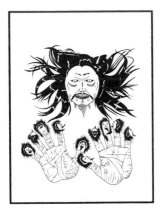

My conscious mind failed me when an image of a man's face appeared in front of me. What was I to make of his stony stare - his piercing eyes coloured like a snowy owl's, and bloodshot, like that of a walrus?

He drew his clenched fists in front of me. Then, one by one, starting with the thumbs, he spread out his fingers. Each finger and thumb revealed a tiny, agonized face, with protruding eyes moving snake-like, slithering in and out of their sockets! Their tongues wagged like tails, trying to say something, but only mumbled, since they were sticking too far out of their mouths to be legible. The pitch of their collective squeal became higher and higher and I had to cover my ears to prevent my eardrums from being punctured. When the high pitched squeal became unbearable, I screamed like a tortured man.

I reached out frantically with both hands to muffle the squalid mouths. Just moments before I grabbed them, they faded into thin air, reappearing immediately when I drew my hands back.

Then there was perfect silence.

I looked at the face, studying its features more closely, trying to figure out who it was. To my astonishment, I realized the face was that of a man I knew well. The devilish face, with its eyes planted upside down, was really some form of an **incarnation** of myself! This realization threw me into a psychological spin.

What did this all mean? Did the positioning of his eyes indicate my devilish image saw everything upside down? Why the panic-stricken faces on the tips of his thumbs and fingers? Why were they in such fits of agony? Had I indeed arrived at Hell's front door and Satan had answered my call?

The crimson sheen reflecting from his jet-black hair convinced me I had arrived at the birthplace of all human fears. His satanic eyes were so intense that I could not look away from them even though I tried. They pulled my mind into a hypnotic state. After some moments, communicating through telepathy, the image began telling me horrific tales of unfortunate souls experiencing apocalyptic terror in Hell's **Garden of Nede**.

The only way I could deal with this supernatural experience was to fight to retain my sanity, as fear began overwhelming me. I knew it would be

Self-Portrait: Inverse Ten Commandments

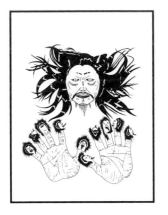

impossible for me to return to the natural, physical world if I did not fight back.

This experience made my memory flash back to the priestly eyes of our local minister of Christianity. He had told us how all human beings, after their physical death, were bound by the doctrine of the Christian Church that they would be sent to either Heaven or Hell. The so-called Christian minister had led me to believe that if I retained my good-humoured personality toward all mankind, I would be assured a place in God's Heaven. But here I was, literally shrivelling in front of an image of myself as Satan incarnate!

I couldn't quite believe what my mind telepathically heard next from this devilish man. As it turned out, the ten squalid heads represented the **Inverse Ten Commandments** in Hell's Garden of Nede. To reinforce this, the little mouths immediately began squealing acidic shrills. They finally managed to make sense with the motion of their wagging tongues. Two words sprang out thrice from ten mouths in unison: "Thou Shalt! Thou Shalt! Thou Shalt!"

I could not believe I was hearing those two words. Why was I the object of Satan's wrath? Had I been condemned to Hell's Hole?

My mind flashed back to the solemn interior of our local church once more where these words had been spoken by the minister: "God made man in His own image." In which case, the Satan could also have made man in his own image. So I was almost sure that I was face-to-face with my own image as the Satan of Hell!

"Welcome, welcome, welcome," the image said, his hands reaching for mine. "Welcome to the Garden of Nede."

I found his greeting repulsive, more so when he wrapped his squalid fingertips around my hands. The slithering eyes retreated into their sockets, closing their eyelids. The wagging tongues began slurping and licking my hands like hungry tundra wolves. I pulled my hands away as hard as I could but wasn't able to budge them.

The rapid motion of their sharp tongues cut through my skin. The cruelty inflicted on me was unbearable! Blood was splattering all over my face and body. I screamed in dire pain.

Self-Portrait: Inverse Ten Commandments

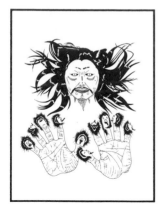

As if by divine intervention, I instinctively looked down between the legs of my Satanic image. I bolted my right knee upward as hard as I could muster toward his triple bulge. My human missile hit its target, instantly freeing my hands. In the same violent moment, the image of myself as the Satan of Hell's Garden of Nede disappeared into thin air. Only a wispy odour of burned flesh remained.

Pitch darkness once again descended all around. Total silence. Calm. Then, peace of mind...

Some days later, when I had arrived back in my camp, I was able to analyze what I had experienced that night. As it turned out, my soul had gone through time and space to visit the dark side of myself as the Satan incarnate. My soul had gone out to scout my safe passage to the cosmos. The only way any soul is freed is for it to get rid of its Satan incarnate at the doorstep of Hell's Garden of Nede. If my soul had not done what it did, it would have remained mired in Hell's Garden of Nede for an eternity after my physical death.

This was a revelation that I did not quite know how to deal with. But it was an essential element of my successful passage to the cosmos as a soul and therefore, the secret to my happiness in afterlife!

Self-Portrait:

Inverse Ten

Commandments

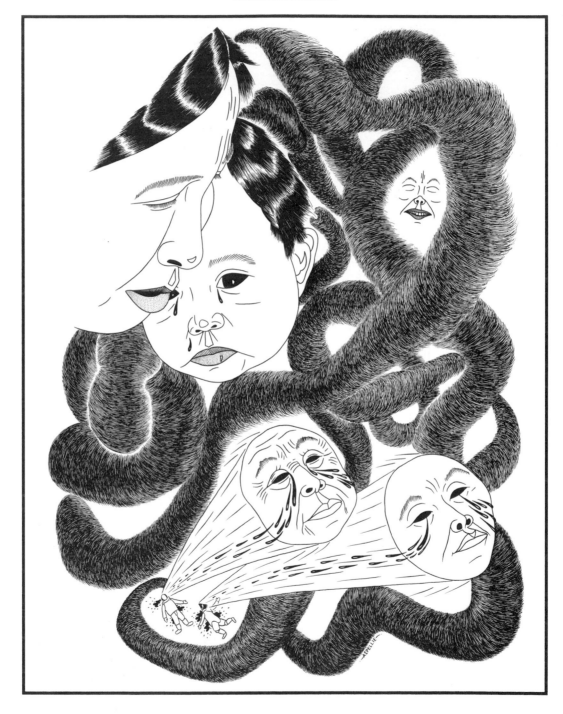

Ascension of My Soul in Death

I discovered myself floating in the cosmos for what seemed like an eternity. I longed to put my feet on something solid, even if it turned out to be back in Satan's Garden of Nede. At least I would somehow regain my sense of belonging somewhere and not be floating in thin air.

I heard a crunching sound in the back of my brain. Something seemed to be breaking. It sounded like hardened snow was being stepped on. The terrible odour of burned flesh again permeated the air. The stench lingered and became more offensive as time passed. I turned around to see what was burning behind me. I couldn't see anything but smoke swirling all around. It got thicker and even darker with every passing second.

God helped me with the realization that, incredibly, I was experiencing the act of my spiritual soul leaving my physical body at the moment of death. My soul was ascending faster than the speed of light through the cosmos, presumably toward Heaven!

Looking up to the distant cosmos, I spotted four silhouettes much like human figures standing at each corner of what looked like a bed. It

seemed they were waiting for me to lay down once I reached their super-natural world. I had a curious feeling those four mysterious figures were really members of my immediate family who had previously entered the realm of souls at the time of their physical death on Earth. These particu-lar four were most probably closest to me personally when they were still alive. I was almost sure of this incredible possibility since I always be-lieved that one day, on such a momentous occasion, I would rejoin my beloved relatives - this time on a celestial level!

This revelation was a wonderful consolation. I could not have imagined this was really a symmetrical celebration of my physical death and the simultaneous birth of my new life as a soul!

As it turned out, it was in the instance of my spiritual resurrection that my dear father, Joanassee, was experiencing the same revelation. His soul was also racing skyward alongside mine! The incredible rush of air against my face was almost unbearable, making my eyes tear. These tears were unlike salty liquid, but were of my own blood. I saw that my father's tears were also of his blood. I found out moments later that, in the supernatural world, any soul carrying human blood cannot enter another realm. A soul has to be cleansed of all its old baggage from the planet

Earth before it can be accepted as a new member in the cosmic land of souls.

It was during the ascension of my soul that my previous life flashed through my mind. The enduring image I saw was the great sorrow etched on the faces of my immediate family. I sensed some heaviness in their hearts, saw the tears flowing out of their eyes, and felt the void and emptiness in their once-vibrant spirits. I observed all this even before they heard the tragic news of our death. Funny how quickly the news travels in the supernatural world. The milling of rumour was never practised so well back on planet Earth!

The death of my physical body gave me clues to what actually happens when one dies. The mind never ceases to work hard to preserve itself for as long as it can hang on. It continues to interpret events during the crucial phase when the soul is being separated from the physical body. This process works the same way dreams interpret themselves in the mind of a sleeping person. So it is in the mind's eye that we experience physical death.

Ascension of My Soul in Death

The reason why the soul travels faster than the speed of light was also a revelation to me. It is because it pities the thought of being trapped in the physical brain and dying along with it and the rest of the body. If it doesn't escape on time, it could not live in another form or in another realm. Once free, the soul wants desperately to go far enough in the distant cosmos to disassociate itself from the helpless and already vegetating physical brain.

Once the soul is safely out of the reach of the dying brain, it will begin to travel throughout the cosmos. It is able to live in the cosmos anywhere from a few minutes to days at a time, or as long as several to many years. More often than not, it usually stays in the vicinity only until its body is buried underground. Then it's free to do whatever it wants to do anywhere in the wide cosmos. This is the phase that is most exhilarating for a soul since it finally acquires the distinction of being the "free spirit" it had longed to be for the better part of its life on planet Earth!

I could not help but laugh at the insecurity I had fostered for a lifetime because of my terrible fear of death. As it turned out, this fear was unfounded! I only ended up compromising my mental and emotional well-

being worrying about my impending death. The only anxiety I should have nurtured was the question of how I would eventually die.

My death was a revelation in another way. I had always been curious about what happens to the soul after being freed from its life-long confinement in the physical brain. In the supernatural world, your chances of continuing to survive in that realm are as precarious as life had been on planet Earth. Your soul rejoins the same family you formerly had in the physical world. It also has an equal number of years to live in the cosmos as it did on planet Earth. Once your soul dies, that is the end of it in any form. There is no truth to anyone being able to live for an eternity, whether or not this "eternal place" is your preconceived notion of Heaven or Hell.

As it turned out, my soul hovered in the vicinity of my dead physical body for a number of days getting ready to enter a new phase in the cosmic land of souls.

And boy, oh, boy! It felt so wonderful to finally be a **free spirit**!

Ascension of My Soul in Death

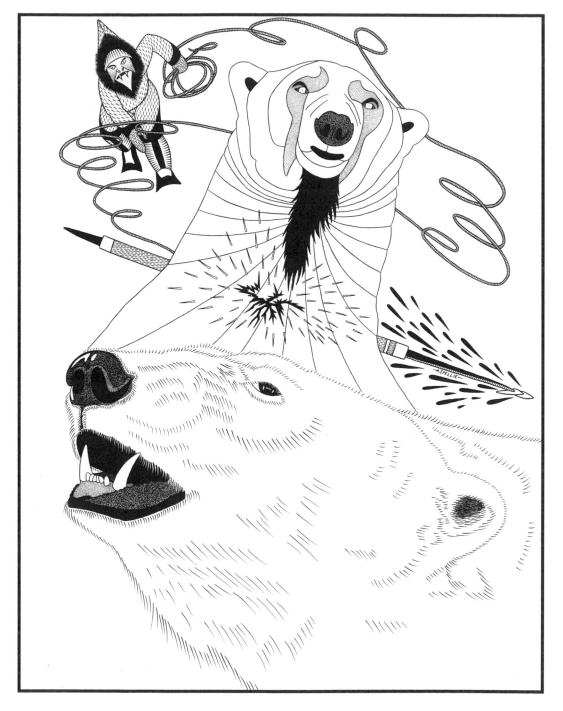

Nanuq, the White Ghost, Repents

The supersonic speed with which my soul had travelled out of my body denied me the opportunity to fully reflect on the true cause of the death of myself and my father. However, like a dream that one finally remembers later in the day, I found out it wasn't by choice that we had left the planet Earth - but by the violent agony of incredible physical pain.

My father and I had been stalking a ringed seal close to a clutter of ice ridges hugging a small island. We had suddenly heard the hardened snow making crunching sounds behind us. But before we could turn around to see what was making the sounds, a powerful polar bear paw had knocked us down. The great white Nanuq, the King of Arctic wild-life, had come to stake his claim to the very same ringed seal we were after. With a few powerful swipes of its claws and life-ending bites from its hungry jaws, the great White Ghost had cut through our flesh and burst open the bubble of our life-blood!

My father and I spent our last few moments in the physical world en-gulfed in the violence of the tyrannical beast. Memorable were the grati-

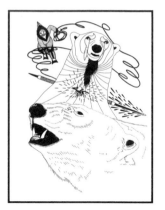

fied eyes of the King, in contrast to our hysterical shrieks and terrified, bulging eyeballs!

It wasn't fair to me and my father that the King never gave us an opportunity to challenge it in battle for supremacy over the Great White Arctic Kingdom. It would have been a call-to-arms pitting the King's natural weapons against our manmade weapons of knives and harpoons. My father and I could only commend the King for its great agility despite its lumbering reputation when walking or running on ice. Its natural instinct as a predator allowed it to do what comes naturally - a couple of well-placed slaps to our bodies - the rest of its job was elementary; sending our souls unceremoniously toward the widening cosmos!

It was from a certain perspective in the sky that I was able to observe what happened next. My older brother, Nuna, who had gone to the other side of the island to watch over one of the other breathing holes, came back to discover a great tragedy. The Great White Ghost was in the act of devouring our bodies when my brother ran up to the towering beast with his harpoon at the ready. He then hurled the powerful darting lance with rage in his eyes. The advancing force of the harpoon became bullet-like as it flew toward its target. My brother's face was so incredibly enraged that

I did not recognize him. He looked like a marauder; a tyrannical man, who had suddenly grown long fangs in his madness. I was astonished how a gentle person like Nuna could become so monstrous during a fit of rage, swearing vengeance for a great injustice done to his dear father and brother!

Finally, his tool of death found its victim. Only a Great White Ghost could growl with such distinction as this one did. Its heart splintered like glass. The pupils turned angelic white. The black blood instantaneously jetted out onto the crystallized ice. What a way to pay for taking away the lives of two innocent hungry hunters! What a bloody shame to have wasted such precious human beings. Then again, that was the nature of our precarious lives; both man and beasts'.

In the land of the wild, no individual is ever favoured over another. When the time comes, no individual is ever spared. No law of nature protects or galvanizes the lives of men or beasts alike.

In the end, Nanuq, the Great White Ghost, was forced to repent in front of my dear brother, Nuna.

Nanuq, the White Ghost, Repents

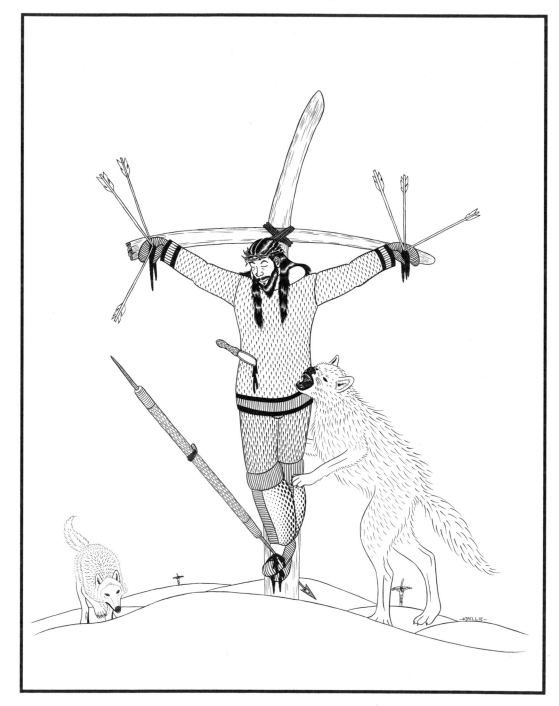

I, Crucified

It seemed incomprehensible, but it took only six seconds for my soul to travel from my dead body to the designated bed in the cosmos.

The psychological turmoil my soul experienced in such a short time expended most of its energy. However, it still took only one second for it to fully recover from the agony of physical death and simultaneous re-birth of my soul.

Moments later, I found out I was actually able to travel back hundreds or thousands of years in time. This extraordinary ability was possible since my mind was finally free from its former life-long prison, the brain. It was peculiar being able to revisit all the important events that occurred during my past lives.

During this particular trip back in time, I saw myself hanging from a cross, crucified. A couple of hungry tundra wolves were milling about. One was gnawing at my hip, the other sniffing at the blood that had dripped from my hands when three arrows punctured both of them. A harpoon was pushed through my feet to the base of the whalebone cross.

A double-edged knife was stuck in the right side of my ribs. For some reason, I was crowned with thorns!

This strange scenario only served to pique my curiosity. Why had I been executed in such a cruel way? Who had acted in the executioner's role?

To find out, I went back to the events leading up to the crucifixion. Apparently, over many years, I had become one of the most powerful shamans living in the Arctic. For this reason, I was virtually the only shaman my fellow Inuit in the camps were willing to hire since they fully trusted me to get results for them. As a result, I could solicit whatever payment I wanted for my services. In many of these cases, my clients often paid more than I expected. My privileged position in the order of the shamanic hierarchy produced feelings of deep jealousy and a certain amount of resentment among my peers. This animosity was especially bad among those who practised their trade in the same region as I.

This particular crucifixion had taken my peers many weeks of careful planning. Then one day, a shaman by the name of Tusujuarluk came to visit me in my camp. In a roundabout way, as the evening wore on, Tusujuarluk came upon a subject that intrigued me. In his words, all the

shamans from across the Arctic were thinking of working together to pool all their shamanic and spiritual powers in an attempt to go on an ecstatic journey to the Milky Way. If we were successful in this unheard-of endeavour, we would eventually explore beyond the universe.

What attracted me to this idea was the strong case he put forward that my fellow shamans could not hope for success in this experiment without my participation. He said if our attempt were successful, it would add to our respective repertoire of shamanic powers. After some reflection and introspection, I agreed to such an attempt. I knew unequivocally that I was the only shaman in the entire Arctic who had the required ability to come even close to attaining such a feat. I was also sure that by acquiring this new additional power, it would make me even more revered than I already was.

When I arrived a week later at a predetermined location, my fellow shamans welcomed me as they would a superior. After all, many of them had been my life-long subordinates, having learned their shamanic trade from me. I fully understood why they feted me. It was because of their great respect for my shamanic powers.

I, Crucified

23

I did not have any inkling of what was about to happen since my fellow shamans often went out of their way to seek advice from me. So I trusted them like they were my close brothers, which they were. But they surprised me this day.

One of the older shamans, the physically strongest of the lot, grabbed my arms from behind! Within seconds, I was bound with sealskin rope around my neck, shoulders, and arms. They cursed me in boisterous tones, like devils gone mad. Never before had I heard such obscenity coming from the mouths of men. Even the filthy tongues I had heard from the spirit world didn't come close by comparison.

Beyond one of the hills, they had staked a whalebone cross into the hardened snow. When we arrived there, the ropes were taken off. I was then propped up against the whalebone where two shamans drove a harpoon through both my feet! At the moment of the harpoon's penetration, I came close to losing consciousness due to the excruciating pain. I could feel my life-blood spurting out of my feet. It took three shamans apiece to nail three arrows into each of my hands to the crosspiece. My jaws snapped at the joints as I gritted my teeth in the agony of raw pain.

Then, Tusujuarluk, who happened to have the closest shamanic powers as mine, stabbed me in the right ribs.

The executioners had completed their job. Moments later, I died a slow death hanging from the whalebone crucifix. Crucified.

It would be another one thousand years before I was to be born again as a new physical being on this ever unforgiving planet Earth.

I, Crucified

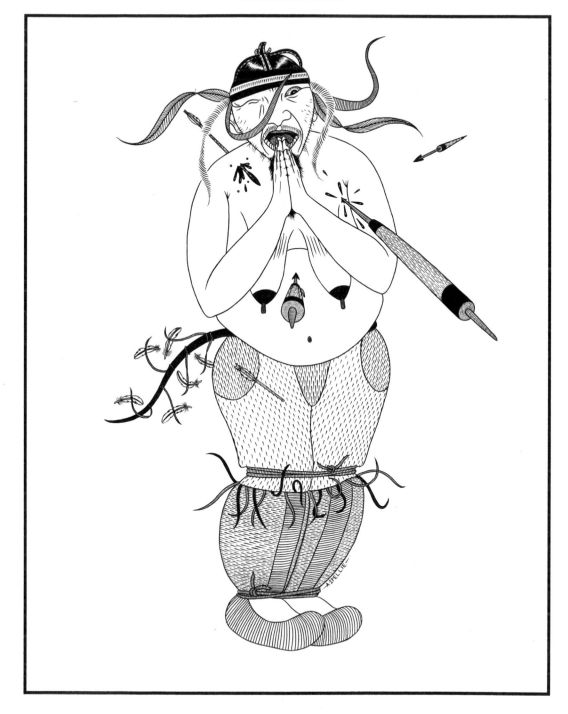

Public Execution of the Hermaphrodite Shaman

One of the most bizarre events that I recall with a hint of humour and humiliation was the day my fellow shaman, Ukjuarluk, was discovered to be a hermaphrodite. He had somehow kept the secret all his life until a promiscuous young woman overwhelmed him with her sexual prowess. One fateful night, she would become the first person to see his real shadow in the dim light of the seal oil lamp inside his igloo.

Ukjuarluk had been travelling alone for many days visiting several scattered camps to fill requests from various Inuit to help them alleviate famine, cure the sick, and perform other worthwhile ceremonies to right wrongs.

One day, he stumbled upon a family travelling from the west in search of better hunting grounds. The Inuit couple had two sons and a beautiful, virginal daughter named Piu. It turned out the father was having hard luck with his hunting. In the course of their initial conversation, the father found out Ukjuarluk was a shaman and asked him to make a spirit journey at nightfall to visit Sedna, the Mother of Sea Beasts, to plead with her to release the sea animals.

In return for Ukjuarluk's help, the father offered his beautiful daughter Piu for the night. It was the only payment he could offer since the absence of game had severely depleted his possessions over the long journey east. Ukjuarluk knew this to be an unusual payment for his services, which he had done for many other Inuit in his time. So, the deal was sealed between the two men. The beautiful, virginal daughter, Piu, being faithful to her father, and more importantly, because she understood it was for the good of the family, agreed.

At nightfall, as planned, Ukjuarluk made the spirit journey of his life to the bottom of the sea. It would be at least an hour before he had completed the preparation for the journey, chanting and drumming, doing a seance to communicate with his spirit helpers, then going down to the bottom of the sea to visit Sedna and back again.

After he was done, he assured the father he should have better luck the next day. Then Ukjuarluk retired to his igloo for the night. Just as he was ready to bed down, the young woman came in. Piu was understandably timid, a little uneasy and incredibly shy at first. After a long while, she finally took off her clothes and then slid under the caribou skin blanket and lay down beside Ukjuarluk. There followed a long silence. In time,

she felt a little better resting on a horizontal plane. She became more relaxed after shedding some guilt feelings about the unusual circumstances. After a few, long yawns, her mind cleared of its heaviness and was ready for what was to come next.

Even though he felt privileged to be in the company of such a beautiful young woman, this experience was a precarious situation for Ukjuarluk. With the passing of each moment, as their bare skin rubbed together, Ukjuarluk was soon sexually stimulated by Piu's caress and the discovery of her sensuous loins. During the height of their expression of mutual passion, which turned out to be sexually explosive, Ukjuarluk would lose all care for his top garment.

The next morning, with the sky still quite dark, Ukjuarluk woke up feeling well rested and sexually fulfilled. He noticed Piu had left before he awoke. After putting on his clothes, he went out to visit the family's igloo. He was eager to see the beautiful young woman again and pay tribute to her parents for having created such a wonderful daughter who would one day make some lucky man very happy indeed.

Public Execution of the Hermaphrodite Shaman

However, when he entered the igloo, it was empty. The family had apparently left early in the morning, perhaps in anticipation of a good harvest from that day's hunting. Their tracks in the snow indicated they were headed further east. It was in the same direction his camp was located. He thought he would meet them again there. He prepared his dogteam and soon headed toward the rising sun.

Finally, he reached his camp in late afternoon. He was surprised to find everyone out to greet him returning from a long journey. They had never done that before. Why was there such an unusual welcoming party?

He was expecting to see happy, friendly faces. What he saw, instead, were stony-looking ones. What had gotten possession of them?

When his dogteam came to a stop, a group of men came and started milling around him. None of them was saying a word. He greeted them with the usual friendly smile, extending his arm for a handshake, as was customary. One of the men, a lifelong friend, took his hand. Ukjuarluk knew right away that it wasn't the usual welcoming handshake. Without warning, his friend grabbed Ukjuarluk's arm with the other hand. Then another man, a distant relative, took his other arm. In quick succession,

his mitts, caribou skin parka, inner lining, and finally, his well-worn top garment were taken off. Ukjuarluk protested violently, bellowing out a primal scream. Now he knew exactly what was happening. The chill of the Arctic wind immediately overtook his naked upper body. His coveted, life-long secret, was formally exposed for all to discover!

There they were. Two, fully grown, sagging breasts!

Every man who touched him knew exactly what to do. It was as if they had rehearsed the scenario beforehand. With military-like precision, they tied two ropes, one around the knees, the other around the ankles. Then they stood him up in the middle of a large circle of men, women and children from the camp. Then the women, who had stood nearby while the men prepared the victim, came forward with harpoons and bows and arrows. They were given the honour of executing the shamed hermaphrodite shaman!

In a matter of seconds, the lethal harpoon weapons were hurled while the deadly arrows sprung from their bows. They travelled through the air with a definite purpose, expending their given force toward the sham of the camp!

Public Execution of the Hermaphrodite Shaman

It was the first, and the last, public execution of a hermaphrodite shaman in the long history of the Arctic people.

Ukjuarluk's wonderful, passion-filled, sexual encounter with the beautiful, virginal young woman had put a price-tag on him. Public execution. Nothing less. Nothing more.

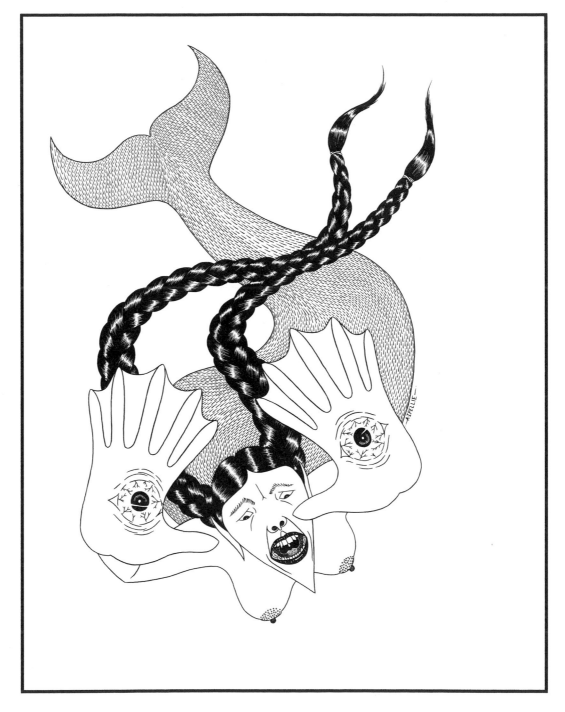

Summit With Sedna, the Mother of Sea Beasts

As a shaman, I had many occasions to visit Sedna, the Mother of Sea Beasts. Making spirit journeys to her home at the bottom of the sea was often perilous. But these journeys were done out of a great sense of duty to my people when hard times beset us.

One winter, a famine was affecting a number of camps in our region of the Arctic. I was curious to know if other regions were having the same problem. So I made a spirit journey in order to contact all my fellow shamans. Indeed, the great famine was not restricted to our area.

A decision was immediately made as to what we, as a collective of shamans, could do to reverse our bad fortune. This was before I found out our respective shamanic powers had greatly diminished in recent months. Sedna, in her moodiness, was directing her vengeance toward all shamans by not granting their pleas to release the sea beasts. I questioned my fellow shamans about the type of encounters they recently had with the Goddess of the Sea.

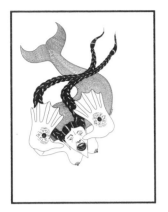

Unbelievably, what I found out from my peers could well go down in history as a **sexual misconduct** that had the potential to wipe out the Inuit nation from the face of the earth! It was the kind of news I could not have fathomed in my lifetime.

From the beginning of winter, Sedna had apparently been making sexual advances to the visiting spirit helpers of the shamans. Although she was well acquainted with certain sea beasts she had control over, she had never been able to have an orgasm no matter how hard she tried. In an act of desperation, she had begun to solicit sexual favours before she would release the sea beasts to the Inuit living in the Arctic world.

My peers didn't really have any choice but to feel obliged to fulfil her requests, fearing their failure to convince Sedna to release the sea beasts might brand them incapable in the eyes of their people. Being seen as a weak shaman would not only diminish their economic well-being but most certainly wipe out their hard-earned prestige among their fellow Inuit. As hard as they tried to use their sexual experience, they had all failed the ultimate test.

Sedna, feeling miserable and sexually bankrupt, had decided to withhold all the sea beasts until a shaman, any old shaman, succeeded in releasing her sexual tensions.

After having heard this unbelievable story, I spent some time trying to figure out a way to break the impasse. Our people's predicament became a desperate situation calling for a once-in-a-lifetime encounter with the Goddess of the Sea. Being one of the most powerful shamans living in the Arctic, I was selected by my peers to prepare a summit with Sedna.

It took me a week to go back and study all my shamanic rituals and taboos that had worked before. Then I had to come up with a new technique that might change the course of our misfortune.

My plan called for all shamans of the Arctic Kingdom to get together for a combined spirit journey to the bottom of the sea. Each shaman was asked to invite their respective spirit helpers which would be collectively moulded to create a giant malevolent creature, a hundred times larger than a normal human being. This new creature would possess spiritual powers equivalent to a hundred spirit souls.

Summit With Sedna, the Mother of Sea Beasts

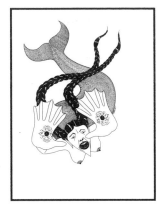

From the very beginning, I knew it was quite unusual planning to confront Sedna in such an unorthodox manner. We had never before gone out of our way to try and make her submit to our demands. Our foolproof method was always to plead with her to release the sea beasts. So it was with some apprehension that we proceeded to try our luck.

Moments after darkness descended over our camp, the ecstatic journey began. I started with a song which I had composed for this particular journey in order to evoke my spirit helpers, as well as those of my peers. It was one of the most complicated seances I had ever attempted.

Finally, after having expended a vast amount of emotional energy through my songs and chants, I was successful in summoning all the spirit helpers to one location. The next step was to make the Earth open so that we could enter it and proceed to find our way to Sedna's abode. Before we ever got close to its vicinity, we had to pass through abysses, fire and ice, and then face Sedna's Sea Dogs, which always guard the entrance to her home.

After successfully passing the Sea Dogs, we got a glimpse of Sedna swimming into her huge bedroom. I motioned the spirit helpers to wait behind

as planned so that I could confront Sedna one-to-one in order to find my bearings with her.

She lay there on her bed, which was well covered with seaweed. Her long, unkept hair had become quite dirty. By the look of her distraught eyes and downturned mouth, I had the inkling she was still quite sexually frustrated.

As was always the custom in my past encounters with her, I immediately started combing and then braided her hair, all the while pleading with her to release the sea beasts. She was perfectly willing to - under one condition. I wanted to know what this condition was. What I then heard was a long, drawn-out preamble to her life-long sexual history, or, more appropriately, lack of it.

It had started when she was still a little girl living in the natural world a few years before she became a Goddess of the Sea. Her father had sexually abused her many times, and when it occurred, it lasted for hours on end. It was because of this prolonged abuse that she became emotionally, mentally, and physically doomed to sexual impotency - unable to have an orgasm no matter how hard or what method she tried.

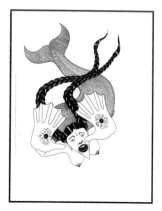

In a last-ditch effort to turn her misfortune around, she had begun to relegate her hopes on the visiting spirit helpers of the shamans from the entire Arctic Kingdom. When an attempted bribe failed with each spirit helper, she would try again with another. This sordid affair continued for the duration of the winter. And now, she was asking me to do the unthinkable! I was perversed by her desperate words.

It was at this moment that I turned and left her bedroom as if I had given up like the other spirit helpers and was returning to the natural world. Sedna began sobbing like a little, trembling child. I understood that nothing would make her sadder than another opportunity lost for sexual fulfillment.

My only alternative was to release our version of **Frankenstein** to confront Sedna. Frankenstein crawled into Sedna's bedroom. Sensing the presence of unusual energy around her, Sedna sat up, moving like a cobra, and turned her head to look over her shoulder.

What she saw behind her was a giant of a monster, more fearsome than any creature she had ever encountered at the bottom of the sea. Franken-

stein stood up and towered over the tiny body of Sedna. Sedna shrieked the hell out of her lungs. She begged the monster to stand back, extending her webbed hands toward the monster's eyes which were streaked with crimson and glowing like gold!

Frankenstein began doing a special chant I had composed for him. It was designed to put Sedna into a trance. This would allow her to have an ecstatic dream - a sensual trip she had never taken in her lifetime. Sedna had become, over the passing of many years, an almost senseless soul, unable to express intimacy in light of her sexual impotency.

During her forced-sensual-dream-trance, Sedna finally met her match. It was her male equivalent, **Andes**, a God of the Sea, who presided over all the sea beasts on the other side of the universe. In her dream of dreams, Sedna had a sexual encounter measurable in ecstatic terms only attainable in the realm of gods and goddesses.

In a state of sexual ecstasy, Sedna released a perpetual explosion of orgasmic juices. In the same instance, during her virgin joy, she released all the sea beasts, which immediately proceeded to travel with impunity to the hungry Arctic world.

Summit With Sedna, the Mother of Sea Beasts

It was beautiful to see the lovely beasts, swimming torpedo-like, toward the breathing holes on the Arctic sea ice. It was wonderful to experience the same excitement of unleashing bottled tension Sedna was going through for the first time in her long vocation!

It was the first time in the history of the Arctic Kingdom that all of its shamans had worked together to avert a certain threat of extinction of its people from the face of the Earth. From this day on, the Inuit were assured survival as a vibrant force in what was oft-times inhospitable Arctic world.

And, more importantly for me, in the eyes of my people, my reputation as a powerful shaman remained perfectly intact.

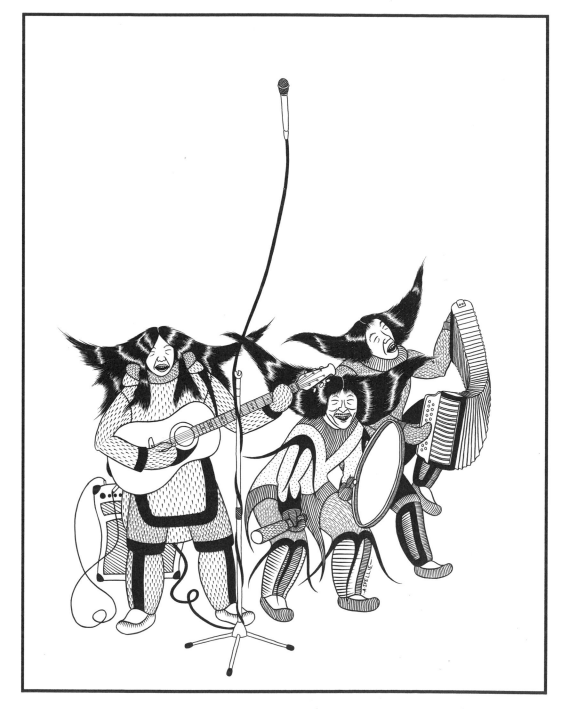

When God Sings the Blues

It was in the middle of the worst winter storm, and on winter solstice, that I had an occasion to get into one of the deepest trances of my shamanic career. All the elements associated with making a successful spirit journey were in play this special day. The wind viciously whipped the snow about. No sun, moon, nor a star, to be seen in the sky. Not a single person or soul around to interfere with my personal aura and energy. I was in a jovial mood knowing I would be making my yearly spirit journey to visit God.

Since I had been a shaman for close to a hundred human years, I had gotten to know God quite well. I was always looking forward to having a long conversation with Him about the year that just passed. I loved to compare notes dealing with the state of the world as it was being handled by the billions of mere mortals who had managed to stay alive for another year.

These visits were the most challenging for me since they were always intellectually stimulating. They were also refreshing because they gave me the opportunity to try my hand at outwitting this particular God.

I used to find it a little ironic that He liked to call Himself by the Inuktitut name, **Sattaanassee**, which meant Satan. I never found out whether or not this was His real name since He had a way of convincing you that He was always telling the whole truth and nothing but the truth. It did not make any sense to me why He had picked such a contradictory name when His job description included an eternal occupation railing against everything His arch rival, the Satan, stood for. This was one of the main reasons why I was extremely fond of Sattaanassee. He never took Himself seriously, not even His own godliness.

I felt like I was the most privileged man on Earth since I was the only person out of billions of people who was allowed to visit Him through my spirit helper. None of my close relatives, nor anyone else for that matter, ever knew I had been making these spirit journeys to see Sattaanassee over the course of close to a hundred human years. The trips were strictly confidential. I would never take the chance of losing my privileges by boasting about my special relationship with the greatest of all spiritual people. It was this iron-clad agreement that allowed God and I to have one of the most private relationships that two spirits could hope for. Mine was a sacred oath that no other single soul before me had ever taken, or would, after me.

It usually took me at least an hour to complete a secret chant. This chant was the hottest ticket to having an audience with Sattaanassee. But before this could happen, I had to fast for a week in order to cleanse my body and mind so that it would be easier for my spirit helper to travel at the speed of light. The preparation was the most important part of making a successful spirit journey to the Magical Kingdom at the edge of our universe.

At times I would be making so much noise inside my igloo while doing my all-important chants that my dogs, who were tied outside, would begin to howl. This was a crucial part of my preparation since the howling of my dogs actually helped to send off my spirit helper. What an extraordinary feeling it was as my subconscious mind began breaking away from my brain and become a free spirit once more!

An hour of chanting would pay dividends as my spirit helper sped upward and arrived at the Magical Kingdom within seconds. Entering the Magical Kingdom was a lot like entering a soap bubble without bursting it. No wonder the Magical Kingdom had a scent similar to an underarm deodorant. One could not take a sniff and not feel like a well-washed

soul. It was always a great relief to be surrounded by such cleanliness after having left the dirt of humanity on planet Earth!

Sattaanassee was a bit of an eccentric who dwelled inside a huge bubble that hovered right at the edge of the universe. A large array of fax machines numbering in the billions, even perhaps in the trillions, never failed to amaze me. They were always printing away, receiving messages from the billions of people on planet Earth praying for salvation after their death. The majority of the messages were asking and hoping for tickets to win the sweepstakes to eternal life inside the Magical Kingdom.

One of the many toys I always enjoyed using was a high-powered telescope inside Sattaanassee's celestial observatory. It was specifically aimed at the planet Earth and had the capability to observe all of humanity at the same time. There was a special command that allowed Sattaanassee to look into and listen in on every individual's mind. What a tragicomedy humanity was living! I could never help but to simultaneously laugh and cry whenever I looked through this special telescope. It was a bit like bird watching, only more intriguing and psychologically rewarding. This was another reason why I was so envious of Sattaanassee. No wonder He led such an interesting life inside the bubble at the edge of our universe.

Another of the sacred truths I was never to divulge to my fellow humans was the unusual fact that Sattaanassee was one of the richest Old Geezers in all of the universe. This was because He took in ten percent of all total donations taken from every single church and institution built in His name on the planet Earth. And it never hurt to own exclusive rights to the biggest-selling book of all time, called **The Bible**. The royalties from this book alone were enough to keep the Magical Kingdom intact for an eternity.

Sattaanassee's method of collecting His royalties and donations reminded me of the different ways the Mafia uses to launder their drug money and other illicitly-earned cash through racketeering and gambling. He dealt with everyone under the table so that He didn't have to pay taxes on any of the money that found its way to the Magical Kingdom. No human being on planet Earth, not even the front men at all the churches and institutions, ever knew exactly how He was able to funnel all that cash. Perhaps, only His hairdresser knew for sure.

So, on this particular spirit journey, I was finally able to hook up with Sattaanassee. When I approached to greet Him, after a year of toiling with a certain number of uncertainties on planet Earth, I was surprised to

When God Sings the Blues

detect something tugging at His mind. I could sense right away that the aura around Him was unusually negative. I had never detected anything like it in the last hundred years of visiting Him.

"Greetings, Sattaanassee, from my humble self, and from the planet Earth," I said, trying to be upbeat about the heaviness of the atmosphere that permeated throughout the Magical Kingdom. "How Art Thou?" I gave Him a warm smile and a wink of an eye. "You amaze me, you know. You never, ever seem to age a bit even after all these millions of years."

"Thanks for the compliment, my friend. It's hard to age when one lives in a bubble like I do. I suppose I am a lucky soul in that way. I am sure you have detected something negative around these parts already. It's been that kind of a year. The faxes I'm receiving from humanity are driving me up the wall! Not a single one of them has a positive tone to it. How would you react to something like that, eh?"

"I know how the past year turned out back home. I think the culprit is the world-wide recession that's hit all the continents, every single country, city and town, from here to Timbuctu. You know about tightwads in business and the out-of-hand government deficits. They've taken over the

planet Earth. We used to be able to spread the wealth around to those who needed it most. Not these days. No more."

"Like, I used to receive one or two positive faxes out of the billions I get every day. This is really strange. Very disturbing. It's just that this doesn't bode well for my business enterprises with billions of people not donating to the churches or the institutions on a daily basis like they used to. Nor is the sale of **The Bible** doing any better than it did yesterday. It's tragic news. It's enough to make you want to commit the ultimate humiliation by living out your suicidal tendencies."

"Come on, Sattaanassee, I think you're taking this a little too seriously. I've never seen or heard you this way. You've got it made, man. Cheer up."

"I'm dealing with it the best I can. And that is to dream and fantasize about all those millions of billions of trillions of dollars that used to end up in the coffers of the greatest business enterprise ever devised by man or God. You know, I wasn't really prepared for this world-wide recession."

"Well, I don't think it'll do you any good to dwell on something as negative as that. I would like to suggest something which might do you good."

"What's that, brother?"

"Well, every week on Tuesday nights, there's usually an incredible Blues Jam called **Blues Tues** in one of the huge dance houses in a winter camp near mine. And this being Tuesday, I suggest we go down to Earth tonight and join some of the best blues musicians humanity has to offer. What do you think?"

"Alright, brother. It might be the tonic I need."

That night, Sattaanassee and I put on an outfit á la **Blues Brothers** and went off to Blues Tues, Blues Jam.

When we arrived at the huge dance house, the house band was already into its bluesy rhythm and groove. Oh, how that solo electric guitar wailed, obviously in lamentation of troubled love. The spirits of B.B. King, Muddy Waters, Sonny Boy Williamson, John Lee Hooker, Willie

Dixon, Sonny Terry, Brownie McGhee, Albert King, Bessie Smith, et al., were dancing to the tunes that made 'em famous.

Sattaanassee's mood instantly became upbeat as Boogie Woogie played to the packed house. The blues afficionados were nodding their heads to the rhythm as others gyrated their pretend-lamenting bodies on the dance floor. Both amateurs, semi-pros on the edge, and professionals took turns on stage playing different types of musical instruments, others taking the microphone to belt the hearts out of their "Memphis Blues". Then on a tune, a soulful face played out a solo harmonica rendition of "cross harping" that would do Sonny Boy Williamson proud. Then the piano blues would take over for a couple of numbers before another rousing "blues shouter" came on stage. What was this if it wasn't Chicago-style blues? Modern blues had an exhilarating propulsion of sound in the manner of rhythm and blues. A fresh-faced up-and-comer would then take the stage, singing in a high, wistful voice.

I could see, in the joyful face of Sattaanassee, that this particular blues jam was the tonic he had been looking for!

When God Sings the Blues

Then, not really to my complete surprise, Sattaanassee signed up to do a couple of tunes! It was great to see the twinkle in His eyes as He waited for His turn to take the stage.

After another rousing rhythm and blues tune, the emcee took the microphone and called out: "Next, we have a fellow by the name of Sattaanassee." There was loud laughter from the audience. "Is Sattaanassee out there? Come on up and do your stuff!"

The three-member house band took to the stage and picked up their musical instruments. They consisted of a couple of young guys, one hugging an electric guitar under his arm, the other an accordion, and an older man using a traditional drum! I had never seen a trio with such a wild combination of musical instruments playing the blues! Then again, where were we? In the Great White Arctic listening to the **Arctic Style Blues**!

The house band stood there for awhile waiting for a guy named Sattaanassee to come up. But no one was showing up. They looked at each other, shrugged their shoulders and began playing an instrumental blues tune.

I smiled knowing a little secret no one else in the dance house knew. The microphone suddenly moved from its socket on the tripod and started rising, seemingly by itself toward the ceiling of the huge igloo! I looked at the mischievous face of Sattaanassee as the crowd gasped in astonishment at the spectacle unfolding on stage. The house band musicians managed to hold their tune as they watched the mike ascending towards the ceiling! Some people in the crowd began laughing hysterically, partly mesmerized by the theatrics of the mysterious mike gone whacko!

"Hello... my name is Sattaanassee..." Again, there was loud laughter. "I'd like to sing you a tune I composed earlier tonight just after I arrived here from the Magical Kingdom... But before I begin, let me explain something about myself to make sure I don't scare you out of your wits. You see, being God, it's impossible for me to be on the same level as you, mere mortals."

There was a hush, then some laughter.

"I can only hover above you, and hence, the awkward disposition of this microphone. You will be glad to know I have nothing to do with this reality since it is one of the sacred laws of the spirit world. In any case, to

When God Sings the Blues

tell you a tiny secret of mine, I've always fantasized about singing the blues to a wonderful audience like you. Without further ado, let's... boogie woogie... to the **Heavenly Blues**!"

The three blues musicians looked at each other, glanced at the dangling mike, shrugged their shoulders and smiled. They began playing "Heavenly Blues" as if they had known it for years. In actuality, the instruments were playing the tune by themselves! Sattaanassee was obviously in total control. The house band soon began gyrating wildly, swinging their hair about, sometimes playing their instruments as if they were saying: "Look ma. No hands!" The crowd went wild, whooping and hollering, dancing the dance of their lives to the boogie woogie of "Heavenly Blues"!

The mike and the wire connected to the amplifier were swinging back and forth, and up and down, to the rhythmic beat of "Heavenly Blues". Sattaanassee, á la Blues Brothers, sang: "Living in the Magical Kingdom / Has given me nothing... but heartache / Looking at humanity... through a celestial telescope / Gives me a stupendous... stomachache / The message from their facsimiles / Renders me... the Heavenly Blues / Renders me... the Heavenly Blues / Renders me... the Heavenly Blues... "

The song went on for another half an hour, "Renders me... the Heavenly Blues..." and slowly faded out. The crowd went wild at its conclusion! Sattaanassee had sung the blues for the first time in His life. It was not to be His last.

When God Sings the Blues

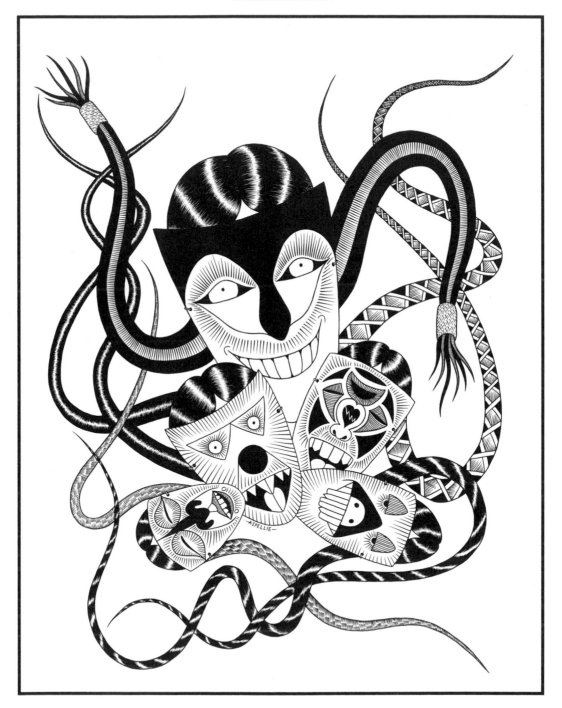

The Five Shy Wives of the Shaman

Many of my shaman associates were also close acquaintances whose families were very dear to me. In an unforgiving land, we had to work on being close knit while struggling with the task of surviving. So it was easy to get to know every member of all the families who were camping with you. As a nomadic society, we were not much different from a pack of wolves who hunted and lived together. It was the only way we survived as individuals.

One of my fellow shamans, a burly man with an easy smile, went about his ways with a peculiar name of **Shakespeare**. The name was unheard-of in the Inuit world since it was not at all peculiar to our language. Shakespeare also had a peculiar way of speaking. I sometimes struggled so hard to get a hang of his peculiar accent that I wouldn't know whether to laugh or cry.

He could recite songs and chants for hours on end, without as much as a break. He also had a certain flair for theatrics, so we were often treated to memorable performances. He was a perfect person to visit during those

long, wintry, stormy nights. Once inside his igloo, you were guaranteed some of the greatest entertainment this side of the northern hemisphere.

One minute, he was a court jester, the next, a brute beast. This left us either aching in the stomach from laughter or frightened out of our wits by his macabre tales. As a performer, Shakespeare was a perfect antidote when the fierce Arctic wind and snow overstayed their welcome.

However, Shakespeare was not the only attraction in his igloohold. To say he was overly fond of marriages wasn't an exaggeration. He had proven it over the course of his life by marrying not one, not two, not three, not four, but, five times!

I will never forget the first time I met him and his family. It was on a fine spring day out on the melting sea ice. My family and I were on our dog-sledge heading to one of our old hunting camps we hadn't visited for several years.

There they were, in the far distance, five dogteams heading in our direction. We soon crossed paths and stopped to greet each other. I recognized

Shakespeare as their leader by the amulets he was wearing around the waist of his outer parka. The amulets were a sign he was also a shaman.

Our families ended up making tea together. A long conversation ensued between Shakespeare and me about what men and shamans only talk about. These were peppered with me asking Shakespeare to repeat pretty well everything he said about being a leader and provider of food and shelter for his family. Shakespeare said his family had broken away from another group of campers in a region I wasn't familiar with. They had been travelling in search for better hunting grounds. I told him about parts of our region and where they might find reasonable game.

The women milled about chattering of womanly subjects. The children listened or occupied themselves with playing games. Altogether there were at least twenty Inuit in Shakespeare's entourage. It turned out that five of the women in his group were his wives. In our culture, it was not unusual to find men who had at least two wives, but five wives seemed a little much to me.

When Shakespeare introduced his five wives, I was taken aback by the curious fact they were all wearing distinctive masks! Whoever designed

The Five Shy Wives of the Shaman

and made them was a true craftsperson. I had an overwhelming urge to laugh, but I managed to hold back with some difficulty. However, my children reacted differently. Some smiled, a couple gave out nervous laughs, and one daughter found them frightful and began to cry.

Here we were, parked smack in the middle of the melting sea ice, enjoying beautiful springtime weather, and I, with a nagging curiosity about those damned masks! I didn't like the prospect of going on to our appointed destination without first finding out about them. So, I put up the gumption to invite Shakespeare for a short walk by ourselves with cups of tea in hand.

When we were out of earshot of our families, I posed the inevitable question. Shakespeare grinned, put his right arm around my shoulders and whispered into my left ear, "They're gorgons."

I couldn't believe what I heard. 'Gorgons?!' I thought, with a hint of astonishment in the back of my mind.

"What I am about to tell you is top secret," said Shakespeare, squeezing his arm a little harder around my shoulders. "One day, not so long ago, I

thought seriously about whether or not my family and I were going to continue suffering humiliation and ridicule from other families about my wives' appearances. 'That's it! I've had enough!' I said, and decided to break away from the previous group we were camping with. I could not stand idly by for another day and suffer along with my wives. It looks to me like we probably never will camp with other families again.

"A couple of weeks before we moved out, I went to an expert mask-maker and ordered five tailor-made masks for my wives. It was the only way we could make a valiant effort to forget the awful taint of our past lives. Those masks have made an incredible difference whenever we have to deal with strangers. When we were about to meet you and your family, my wives put on the masks. Once we depart from here, the masks are taken off again. You get the drift?"

"Yes," I answered. Shakespeare and I were now sitting side-by-side on a snowdrift, facing our families a short distance away. "I find it a little sad. It's unfortunate, especially for your wives. What an unorthodox way for them to be dealing with people. But I do understand why it had to be done. What can we do about the realities of life in this cruel world?"

The Five Shy Wives of the Shaman

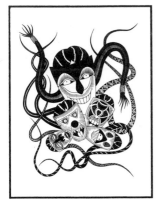

"I wanted to croak whenever my wives had to face other people in the last camp. I suffered along with them. The only way they could deal with people other than the members of our family was to literally cover their faces with their hands or arms. But mostly, they hid behind the fur of their hoods. Even when they faced people openly, the people could not look at them for any length of time. This is no way to live in this world. Something drastic had to be done. The solution was the donning of the masks."

"I hope you will not be offended when I ask you this question. How did you ever end up with five gorgon wives?"

"Desperation, I suppose. I was never very comfortable with attractive or beautiful women mainly because I was an extremely shy person. As it turned out, I got along famously with these particular gorgon women because they had similar personalities to mine. They were social rejects while I, more or less, rejected society. So, whenever I met a gorgon woman who had no hope of ever getting a husband, I felt obliged to do the honourable thing and proposed to their parents for their daughter's hand in marriage. As you can imagine, their parents were happy to marry them off since I was the first and the only man who had ever shown

64

interest in their daughters. Medusa would have been proud to marry me too."

"Well, Shakespeare, you are a courageous man. A lesser man would have broken down in humiliation under the ridicule you and your wives and children have had to endure."

"It's just a question of pride. If you have any pride at all in yourself and your family, you have to be courageous in these terrible circumstances. I made a conscious choice to marry these women, therefore I have to prosper or suffer, live or die, with them."

"Shakespeare, I applaud you."

"Thank you for your support. I will convey your feelings to my wives later tonight."

Shakespeare and I stood up and started walking back to rejoin our families. We still had a long journey ahead of us to our appointed destinations in opposite directions. Before we departed, Shakespeare and I agreed that we would meet again in the fall just before freeze-up in one of my

The Five Shy Wives of the Shaman

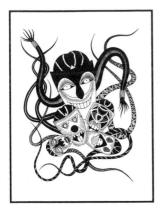

family's winter camps in the region. This was a major coup on my part since Shakespeare had earlier said his family would never live with other families ever again. I was able to convince him he should at least give it one more try.

Moments before our dog sledges were ready to move on, Shakespeare came over to shake my hand farewell. He was smiling like an old friend. He knew it would probably do more harm than good to himself and his family over the course of time if they continued to keep the secret behind those masks. He had certainly helped his wives' cause by revealing everything to me this day. It was to be the beginning of a long friendship.

As our dogs barked and howled in great excitement pulling away, I waved at Shakespeare. What a peculiar character he was. What a cast of equally peculiar characters he had in his entourage!

I will never forget what he had whispered into my left ear about his five shy wives. "They're gorgons."

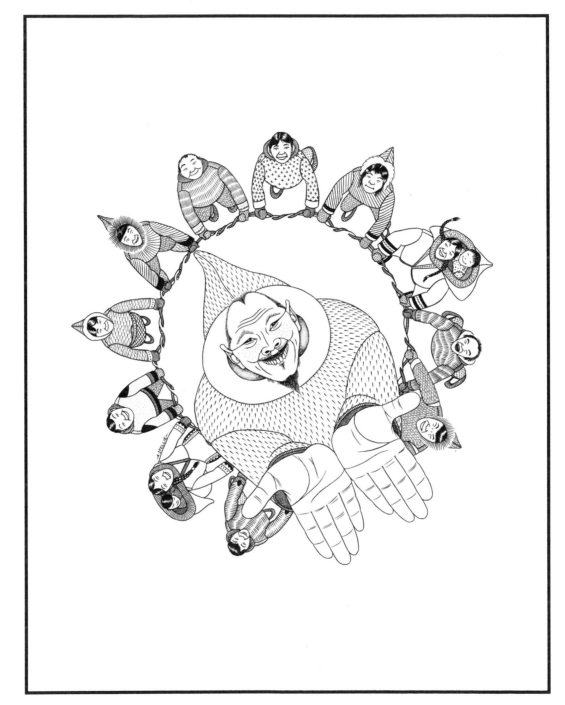

Trying to Get to Heaven

"Heeeeeeeave! Hoooooooo! Heeeeeeeave! Hoooooooo! Heeeeeeeave! Hoooooooo!"

I was startled by the hollering while trudging along the tundra hunting for caribou on a warm mid-summer afternoon. The hollering was coming from behind a hill alongside a river. I could hear quite a few people cheering and chattering. It sounded like they were doing a communal thing. I wanted to find out what it was.

The noise got louder as I got closer. Just as I was about to climb a small hill that separated me from the noise, I was aghast to see a man flying upwards! He was screaming as if in celebration. He was ascending for a long while. Then his momentum stopped. He was soon falling back down. The spectacle stopped me in my tracks. The dogs barked at the flying man.

"Heeeeeeeave! Hoooooooo! Heeeeeeeave! Hoooooooo! Heeeeeeeave! Hoooooooo!"

There he went up again! This time he went even further than the last time. "Awwwwwwwwww!" he yelled as he descended once more, with a wide smile.

"Heh, heh, heh," I laughed. "What's this?"

"Heeeeeeeave! Hoooooooo! Heeeeeeeave! Hoooooooo! Heeeeeeeave! Hoooooooo!"

"Yeeeeeeeahhhhhhhh!" he yelled as he headed toward the sky. This time he went up for quite a long time. He was suspended in mid-air for five, six, ten seconds, looking upwards, palms together as if he was presenting himself to the gods. Then he looked back down as he descended once more. "Almoooost!" he yelled, grinning ear to ear.

When I reached the top of the hill, I discovered a group formed in a circle, holding a sealskin blanket and tossing this distinguished looking, older man. They were all in a jovial mood. I thought they must be celebrating something as was the custom with the annual blanket toss.
I stood on top of the hill for a few minutes observing the ritual. My dogs barked every time the man went up in the air.

"Alright...." someone called out. "Heeeeeeeave! Hoooooooo! Heeeeeeeave! Hoooooooo! Heeeeeeeave! Hoooooooo!"

The man was flying upwards once more. This time he went up, up and up, until he disappeared behind the clouds! We did not see him for about 30 seconds. The dogs' barking turned into a whimper. Then suddenly the man reappeared from behind the clouds, descending at a very high speed. "Woooooooow!" he yelled, wide-eyed. My dogs began barking wildly. It was easy to figure out they were enjoying a spectacular show.

I started down the hill to join the celebration. My dogs began wagging their tails. They were as excited as I. This was totally unexpected. How often did we run into a blanket toss while hunting for caribou on the tundra?

It seemed a little surreal to be watching this man being tossed way beyond the clouds. The highest I've seen anyone go up was 25 to 30 feet, at the most. These guys must have been doing this for a long time if they could toss a human as high as they were. I was amazed at their incredible feat.

I sidled up to a chap standing back from the blanket tossers. He was obviously enjoying the show. "What's up, Doc?" I asked.

"Shaman Qilaliaq," the chap answered, nodding his head up and down. "He's trying to get to Heaven," he grinned, nodding his head once more.

I burst out laughing. I had to put my hunting gear down on the ground because I was losing my energy fast - laughing from the belly. My dogs started barking as if they were laughing from their bellies as well.

"Why are you laughing? This is serious business."

I laughed even louder and in a sustained manner. I found myself lying on the ground, laughing to death! My dogs were doing the same thing, rolling around on their backs on the tundra! "Trying to get to Heaven?!" I yelled over the celebratory noise of the blanket tossers.

"Serious business. **Serious** business," the chap said standing over me and pointing an index finger right between my eyes.

Suddenly, there was dead silence. I kept on laughing from the belly. It was as if a laughing machine had been turned 'ON' inside me. My eyes welled. I started crying with laughter. My dogs seemed to be imitating me as parrots do their masters!

The people started milling around me and my dogs. They looked at me, then looked at each other, in total silence. My dogs and I kept rolling around on the tundra. My laughter turned into a hysterical laugh the harder I tried to stop.

As I laughed, I was recalling a fellow shaman, Tookeetooq, who, after the introduction of Christianity to his people, believed he could get to Heaven just as Qilaliaq was attempting to do. As the story was told to me some years back, Tookeetooq had first built a huge igloo with the top open so that he would be able to ascend to Heaven through the opening. He invited all the people in camp to this huge igloo. As Tookeetooq had planned, everyone soon began singing and chanting while a man beat a rhythm on his drum. Tookeetooq had announced beforehand that he was going to Heaven by jumping up through the opening of the igloo. And to make sure that it would be easier for him to ascend to Heaven, he discarded all his clothing. There he was, stark naked, balls and penis thrash-

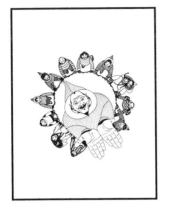

ing about as he leaped higher and higher. He kept at it for a long time. In the end, he collapsed from exhaustion. Being a mere mortal, Tookeetooq was also a total failure.

The next thing I knew, as I continued to laugh hysterically, the group picked me and my dogs up and put us on the blanket toss.

"Heeeeeeeave! Hoooooooo! Heeeeeeeave! Hoooooooo! Heeeeeeeave! Hoooooooo!"

We were racing towards the sky! I looked down at the blanket tossers on the ground who were getting tinier and tinier by the second. We went past the clouds and kept ascending further into the darkness of the universe. We never descended back to Earth. We had been tossed up to Heaven, still laughing hysterically, instead of Qilaliaq!

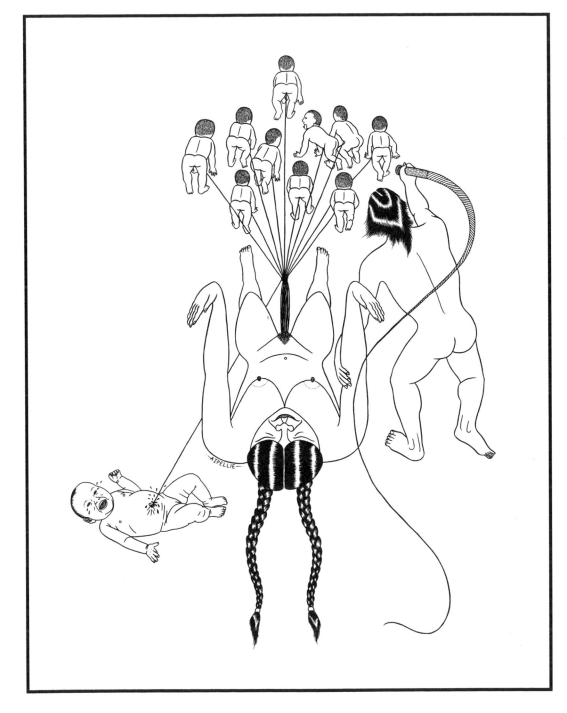

The Dogteam Family

One of the great pleasures of life on the land was in being able to travel the sea ice in the wintertime. A solitary traveller, as I often was while doing my shamanic chores, could feel immense peace of mind gliding along the accumulated packed snow on top of at least three to five feet of frozen sea ice. The expanse of the landscape made you feel like you were the only man on planet Earth. It was easier to breathe in such circumstances when nothing or no one interfered with your daily progress.

Those incredible working husky dogs were indispensable to me and my family. I had so much pride in their physical power. During long, chilly winters, a strong dogteam made life of nomads easier to deal with. The dogs knew exactly what their role was, and that was to work hard - each day - depending on the time of year. Winter was their busiest time, hauling all our camping and hunting gear for long distances. They did it without as much as a complaint, content and happiest to be pulling and working together with their lead dog.

Often there was rivalry among the dogs, especially between the strongest males in the pack. So, occasionally, I had to break up a vicious fight be-

tween two huge and powerful huskies. It was often hard to break them up once they were locked in their mindset to win at any cost. Their prestige and reputation was always on the line - just like human beings. The only way I could stop their fighting was to hit their skulls hard with the wooden handle of my whip. Their fighting spirit went especially acute during mating season. These were times when it was harder to stop them from fighting since their natural rivalry became more intense.

Feeding time usually took place when they were tied down separated from each other. This ensured every dog got a fair share of rations instead of having to deal with the pecking order that often occurs in different wild animal colonies. The most common dietary ration was the remains of the ringed seal, which was most common in the Arctic. The other was Arctic char, found in most of the rivers and lakes.

The birth of a litter of anywhere from six to ten was always a special occasion. This meant joy within our family and especially for me because it ensured the continued survival of the husky as an integral part of our culture, and usually, it replenished my team. It also meant that our children would acquire pets while the dogs were still puppies. Once the huskies joined the others as working dogs, they were no longer consid-

ered pets. As a pack, the huskies were known, occasionally, to attack a child when he or she somehow became isolated from their relatives. So there was a strict rule to have them tied up when they weren't pulling the sledge for us.

Young dogs were often allowed to roam free as we drove along the sea ice since we considered them to be safe and they had reason to stick with us wherever we went. They were being trained to take over from other huskies that eventually died of old age. Puppies, only days or weeks old, would ride on our sledge, since they were still incapable of keeping up with us on their own. They were always a great source of amusement for our children, who often imitated the adults by harnessing the puppies to their play sledge during camping stops. These cute little creatures would eventually turn into powerful beasts.

The lead dog was usually a female and one of the most intelligent of the pack. She knew every command I gave her and never failed to obey. There were occasions when I had to use my whip to get some of the dogs in line or to make sure they were following the lead. Very often the snap of my whip signalled the dogs to get moving from their slumber. They were always full of energy and excitement when we were preparing them

The Dogteam Family

for a run. They knew that it was their calling to be working dogs. It was a wonderful feeling for me as an owner when they were howling and barking as they started out on a long trip to the next appointed destination.

These dogs were also very able travellers during vicious snow storms when we had to get on with the task of reaching our destination. Their reliability in these circumstances spoke volumes. And, as we stayed inside our igloos during a whiteout snow storm, they rode the storm by simply curling up on the sea ice and let the wind cover them with the snowdrift, giving them the shelter they needed to stay warm, to protect them from the bitter cold.

One other, although gruesome, use for some husky dogs was to be killed and eaten by people suffering from famine or starvation during harsh winters. Under such circumstances, if a group in a camp weren't finding animals for long periods, the dogteam would eventually dwindle in numbers as they were being eaten one by one, often the weakest going first. We had no choice but to do this since it prolonged human survival until the land provided for us again and to allow us to ride out the harsh winter into the coming of spring that promised better hunting and gather-

ing from the land. After an especially bad famine, a family would end up eating all their dogs. And in desperation, after all the dogs had been eaten, and there was still no animals, those humans who died of starvation became victims of cannibalism by members of their families. Such was the macabre reality of being a nomad in an unrelenting Arctic world.

In the summertime, the husky dogs also had useful purposes when we had them carry some of our hunting and camping gear by donning them with saddle bags draped on either side of them. These saddle bags were also used to carry meat during caribou hunting trips on the tundra.

And in the wintertime, we often used our dogs to find a seal's breathing hole, which was hidden from the naked eye. Without their reliable noses acting as a detective in the manner of Sherlock Holmes' magnifier, we would otherwise be looking for such a hole for hours on end. We always had renewed respect for their incredible sense of smell every time they located a seal hole.

A dead dog also had a useful afterlife since we used its skin for the rim of our hoods. This was an effective way to keep the relentless cold and wind and snow from biting our face. The skins were also used for mats inside

The Dogteam

Family

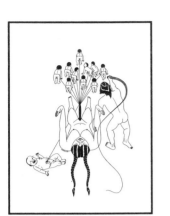

the igloo and as foot or knee rests during our long wait for the seal to come to its breathing hole.

Another role the huskies played was to help us hunt the giant polar bear. When we spotted such a beast, we would release the dogs, that would eventually surround the great Nanuq until we could get close enough to harpoon it. I was always amazed to observe them doing their chore. It was as if they had been trained to do what they were doing.

Usually each of our husky dogs was given a name for identity. Miraculously they would get used to their names in time.

It was not unusual to meet up with other dog teams while on a lonely trip on a particular shamanic chore. Most of the people I met were those I had met on previous trips. These were always cordial gatherings that permitted us to tell each other one or two stories over tea and a bite to eat before going on.

Each hunter had a distinctive team and variation in number of dogs, size of sledge, and so on. One could tell by the state of their husky dogs how prosperous or lean the hunting of game had recently been for them. The

healthier the dogs, the less labour it would be for the owners. The leaner the dogs, the more struggle and slower the travel would turn out to be. Having a strong and healthy dogteam provided a great sense of pride for a hunter. It also showed how great or mediocre a hunter he was.

One year, I got a call from a particular camp that took me a week to reach. Three days into the trip, I spotted a dog team in the distance going in the same direction. I was curious to know who the lone driver was. So I directed my team to meet up with him.

Getting ever closer to him, I could see that there was barely anything on his sledge. When I was within a few hundred yards, I was astonished to discover the dog team was not a conventional dog team at all.

There was a man driving a team alright. But the man was using a woman, probably his wife, for a sledge! A team of infant children were pulling their mother with their umbilical cords still attached to their belly buttons from their mother's vagina! The mother was lying on her back, her arms stretched straight up in the manner of sledge handles common only to Greenlandic dog sledges. One of the umbilical cords got caught on an ice ridge jutting out of the sea ice and the infant was being dragged behind as

The Dogteam Family

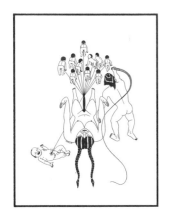

the team sped along. She was crying in great pain. I could see that her belly button was bleeding profusely.

The whole team was totally naked in sub-zero temperature! The man would run along the woman sledge and then sit back down again on her belly as the team of infants ran in great speed. They knew exactly what to do when the man gave them directions in avoiding ice ridges, when to slow down and speed up again. What made this an even odder scenario was that the man was directing the infants in the same manner that I do with my own dog team! Did it not make more sense to signal them in Inuktitut since the infants were all Inuit?

The woman seemed perfectly content to be sledging along the sea ice, eyes closed as if she were in meditation. Every bump on the rolling sea ice created luscious bouncing breasts. I found it hard to imagine she was in no great pain even as the infants' umbilical cords pulled hard from her vagina or when the man sat down, putting all his weight on her belly.

The part I could not understand, for the life of me, was how these naked bodies were not already frozen solid in the god-awful cold. It seemed

they were oblivious of me even as my dogs barked and howled when we caught up with them.

"Hey!" I shouted at the man. He turned his head around in my direction. What a shock to see he had no face! It was just smooth skin like a finger-print!

I didn't know how to react. What was I to do now?

The man wasn't stopping and didn't seem to care that I was sledging alongside his team. He just kept getting up and running beside the woman and urging the infants to keep speeding.

"Can we stop?!" I shouted to the man. "Can we talk?!"

He shook his head. At least he heard me. He cracked his whip and hit one of the infants who gave out a loud cry. The infants seemed to be well trained, and for their size, they had an easy time pulling their mother and father along the sea ice.

The Dogteam

Family

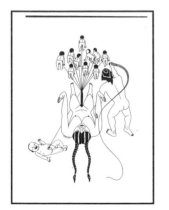

"Damn human! Leave us alone!" The man cursed and cracked his whip rapid-fire five times in a roll. Soon the dog team family was racing way ahead of me. I could not keep up with them due to the heavy load I was carrying.

I gave up chasing after them when they turned to the right and disappeared behind an island. I was not about to further antagonize the man. He wanted nothing whatsoever to do with me. I was ready to accommodate him.

Later that night, as I lay ready to go to sleep, I had a remarkable vision on the ceiling of my igloo.

It so happened that the woman from the dog team family had been pregnant for a long time. When she was due, she gave birth to a litter of eleven children at the same time! I was amazed to find out that the infants were attached to their mother permanently since the umbilical cords are never cut, as they are in normal human beings.

I was also surprised to learn that the dog team family actually belonged to the Dog People Society which is secluded from the rest of humanity. They live in the netherworld never visited by human beings, somewhere in the vicinity of that huge island which the Norsemen called **Greenland**. The Dog People alone have exclusive right in being able to get in and out of their private domain. Being Dog People, they have no need to wear clothing even in the dead of winter.

They are rarely seen by the human eye, preferring to come out into the world only after dark. It was by pure luck that I ran into them this day.

The Dogteam Family

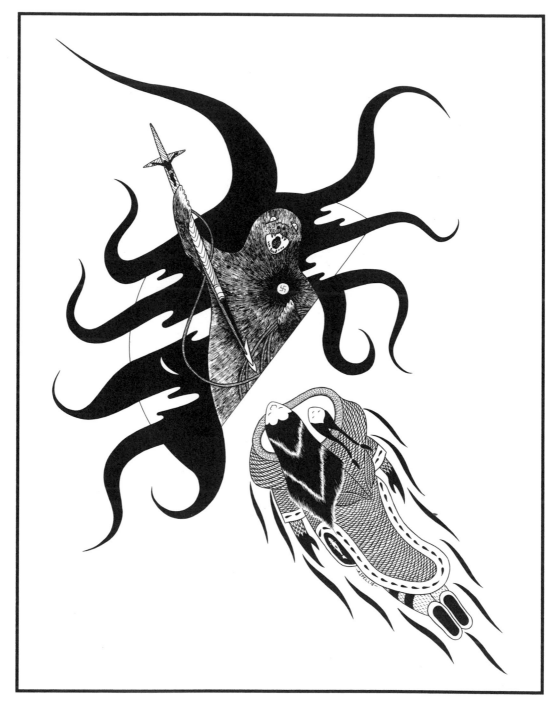

Survival of the Most Violent

It was an ideal spring day. When I arrived at the open water on the edge of the sea ice, I prepared to launch my qayaq to stalk a seal I had spotted in the distance. I soon paddled off in pursuit with my harpoon and float at the ready.

The seal was swimming at a leisurely pace. And by experience, I knew it would not be long before I caught up with it. Its head would pop up between the flow ice to breathe before submerging once more. It was always a guessing game when and where the seal would surface again. As a hunter, this is what kept your adrenalin going with great expectations.

As I paddled quietly on, looking with anticipation all around me, something or someone turned my qayaq around so that I ended up submerged in the water, unable to come up for air again! I held my breath for as long as I could before I blacked out.

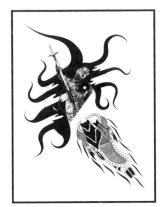

When I regained consciousness, a remarkable transformation had taken place. There I was, on top of the sea ice waiting above a breathing hole. I had traded places with the seal world, becoming a human hunter who craved human flesh for my next meal!

Finally, the salt water below me began to move and I took my harpoon and plunged it into the neck and shoulder of a beautiful human mother with her daughter riding in her amouti. What a rush it was to see those human faces coming up for air!

It was a human hunter's dream of dreams to harpoon a mother and child since they possessed incredible tenderloins. The killing of the female human species made us avoid having to tenderize the male of the human species before we ate them.

It was a great struggle to pull the mother and child from the water due to her huge amouti, which doubled its weight when wet. But once I got them on top of the ice, I wasted no time in cutting up the mother and going straight for the liver, which was the most delicious part of a human being. There was never a substitute for human blood that was so rich and kept you warm for a long time after you drank it. I was always careful not

to eat the eyes, since they were usually reserved for the females in our seal world. Often I would fill myself with human flesh before stitching close the corpses and happily pulling them back to camp where my family would soon feast on them.

None of the human body was ever wasted or thrown out since we had a use for all of it in some way or form. For instance, we would clean the bones and use these as various household utensils, as part of our sledge, or make them into weapons like harpoon heads and arrowheads or toys for our offspring. Depending on the season, we often braided their intestines and put them out to freeze in the wintertime or in the summer boiled them in a pot. The hair we intertwined or braided to use as string or rope. Fingernails we snapped off and used as guitar picks. The skulls we would make into ladles or bowls. We would carve and string together several bones to make bows. The skin we used as floats or to make carrying bags with. And when we came upon tough-skinned gentlemen, we were able to use their skins to make watercraft. The pelvic bones were particularly useful to make small seats by stringing four of them together. By leaving the rib cage intact, it served perfectly as a baby carrier much the same way Inuit women carry babies in their amoutiit. Sometimes, on

Survival of the Most Violent

special occasions usually on Hallowe'en, we made scary masks of their bony skulls by cutting away the back half of the skull.

In the seal world, human beings are the prize catch of any hunt at any given time. Such delicious food!

The seal's constant struggle for physical survival has always been more prevalent than his moral or spiritual struggle. For this reason, a seal, of all the creatures that has ever lived on the planet Earth, has been the most violent. Seal history has graphically proven this with bloody examples strewn on every corner of the Earth.

God help us all when we are now capable of imagining what we may have thought was unimaginable to the seal mind. We have only to be reminded of the horror of horrors that was practised on innocent seals during an era we have come to know as the wildlife Holocaust. The atrocities committed at that time are proof enough that a seal possesses one of the most violent minds that has ever existed upon the Earth.

Just as moral struggles can create violence among seals, spiritual struggles among religious denominations have often incited the violent nature of

seal species. The crucifixion of Jesus Christ, as popularly reported in the Holy Bible, is a perfect example. The spiritual leader of all devout Christians was their great hope for salvation from damnation to eternal hell fire. There have been numerous wars waged between opposing religious factions throughout the ages. To this day, it seems, these spiritual struggles and the resulting violence will never stop as long as the seal lives on Earth.

The Arctic world has had its fair share of violent moments. The human being, through the eyes of its soul, knows exactly how it feels to be slaughtered senselessly. They have come to understand that the brutal force of the harpoon is used so that another creature, in a shared planet, may survive for another moment and another day.

For a human hunter, one of the most satisfying rewards of his conscience is to kill a human being as beautiful as the mother and child for their valuable meat, skin and bones. It is pure ecstasy to plunge a harpoon into the flesh of a human being with great force, to finally see the brilliant crimson color of blood appear in the salt water; to be elated with a sense of great accomplishment; to fulfil a dream of feeding the emptiness in the

Survival of the

Most Violent

centre of our frugal bodies. This we do with the violent death of our fellow creatures of the Earth. Such is the nature of seals.

The brutality we bring to this world becomes acceptable to all when we justify it with the cruel fact that we would soon perish from the face of the Earth if we abstained from the act of violence for too long a period of time.

The seal has pretended for centuries to be benevolent with abject failure. It is doomed to remain a 'brute beast' as long as it exists. The seal has created a creature of itself, which is able to obliterate their sealkind, and all other living creatures, with a simple launching of nuclear weaponry. This reality in itself is a cruel joke that a seal can only laugh at if it is ever made into a film in the manner of a black comedy.

And so it is not the survival of the fittest anymore. Nor is it the survival of the most intelligent. The cruel fact remains that, since sealkind has been on the planet Earth, the dictum has always been **the survival of the most violent**.

This is true for today and, for tomorrow.

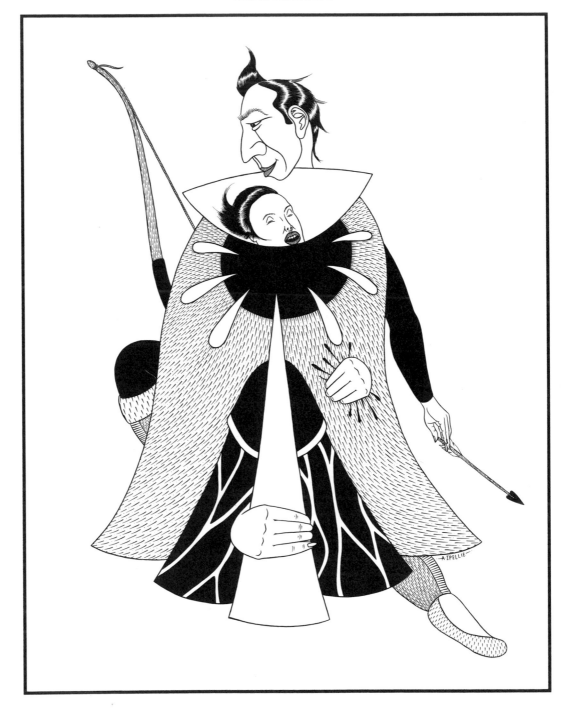

Super Stud

"It's a bird! It's a plane! No, it's Super Stud!"

I stopped my dog team and looked up in the blue yonder. It seemed like just a flash. People were pointing at it as it zoomed back and forth in the sky. "What is it?" I asked a bystander whose head was rotating left to right as if watching a championship tennis match at Wimbledon.

"It's Super Stud! Faster than a speeding arrow! More powerful than a dog team! Able to leap tall igloos in a single bound! It's the man of cupidity!"

"The man of what?"

"Cupidity. The man of eager desire. Otherwise called **Cupid**. Flies around the wide expanse of the Arctic with a bow and arrow looking absolutely lovelorn. He also has a nickname. 'Eros'. Heh, heh, heh."

"Eros?"

"Yep, Eros. God of Love."

"I've never heard of such a man. Where did he come from?"

"The rumour has it he arrived here from a planet called 'Krypton'. Strange fella."

"Super Stud? Cupid? Eros? God of Love? Strange fella, indeed."

I continued my journey determined to find out more about Cupid. He was flying back and forth across the blue yonder faster than a speeding arrow.

When I arrived in camp, I immediately went into a trance in an attempt to connect with Cupid. I caught up with him as he flew, bow and a heart-tipped arrow at the ready, looking down and sizing up some women on the ground. He seemed particular about his selection. Then he loaded his bow and carefully aimed at the heart of one beautiful young woman. Miracle of miracles, he was right on target. I couldn't help but laugh at this seemingly incredible spectacle!

Cupid then swooped down to the young woman laying on her back, an arrow protruding from her heart! He picked up the woman without stopping, as falcons do their prey, and flew off toward the mountains. Curiosity got the better of me so I ended up flying along with them.

Faster than a speeding arrow, we flew close to the summit of a mountain. Cupid turned around a rocky shoulder and disappeared into a cave. I tried to follow him but was prevented by a huge steel door that closed like a garage door! Some activities, I suppose, are better left unseen. Who was I to intrude the privacy of Cupid's bedroom? After all, it was none of my business. I had a pretty good idea what was about to ensue behind that steel door.

Faster than I could blink, Cupid flew out of the cave. The beautiful young woman was wearing a dreamy smile on her face. Eros, the God of Love, had obviously influenced her facial expression.

We flew back to where Cupid had arrowed the heart of the young woman. Cupid put her on the ground and she happily trotted along to her igloo in the vicinity.

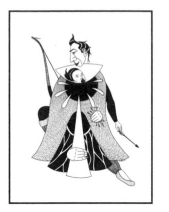

Cupid flew off again, this time to another camp situated in the mouth of a spectacular fiord. He was soon brandishing his bow and taking out another heart-tipped arrow, flying back and forth in mid-air, searching for the perfect score. I laughed at this repeated spectacle.

"Here! Here! Here!" A woman's voice was yelling out. Cupid turned his head toward the voice. An old woman, apparently widowed, was laying on the ground, legs spread open, waving her arms wildly at Cupid. I had to laugh. Just a little laugh.

Upon closer inspection, the old woman wasn't wearing any pants or underwear! One could see the ancient bush all exposed for Eros, the God of Love! Cupid didn't quite know how to react. What to do with a desperate old woman who hadn't been penetrated for years, perhaps decades? Who was to know, maybe she had never had a man before?

"Take me! I'm yours!" The frail voice yelled again. "Pleeeese!" She began to cry feverishly, pointing at her crotch.

Cupid paused, scratched his forehead and inspected the old woman. "Hmmmm... nothing to lose... could be interesting... " he said, aiming his

arrow in the direction of the old woman who was panting and sweating like mad.

"Yesssss!" the old woman moaned as the arrow hit its mark. Faster than the speeding arrow, Cupid was heading back to his cave, the old geezer slung over his arms. I grinned ear to ear at the thought of Eros doing a trick on the feverish old woman.

Within a blink of my eye, the steel doors opened and out came Cupid with the old woman who was laughing like an old wretched witch. She couldn't stop kissing Cupid's cheeks, back and forth, with gusto.

When Cupid put down the old woman where he had found her, she trotted off into camp with a bounce in her steps, bent back humping up and down. She wore a remarkable grin, and there was a sparkle in her eyes.

After having had a glimpse of Super Stud's astounding stunts, I went back to my camp. People were pointing to the sky. "It's a bird!" one of them shouted. "It's a plane!" another shouted.

Super Stud

"No, it's Super Stud!" I said.

"Super what?" one of them asked.

"Super Stud! Faster than a speeding arrow! More powerful than a dog team! Able to leap tall igloos with a single bound! It's the man of cupidity!"

This was the incredible story of Super Stud, one of the best-known servicemen to womankind in the Great White Arctic.

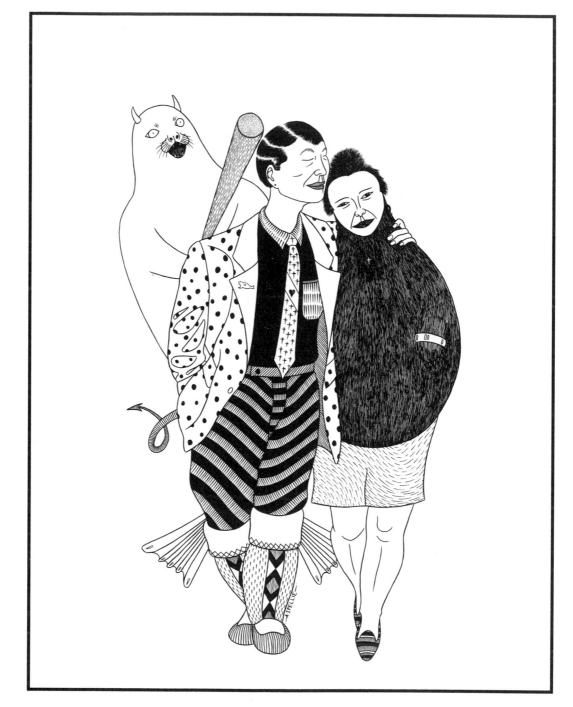

After Brigitte Bardot

My family and I were expecting to spend a quiet spring minding our own

business hunting and gathering seals, doing some fishing at a nearby

river, and going after ptarmigans and waterfowl that were once again

arriving from the south. It was a ritualistic relocation we had religiously

followed for decades. As arrival of spring goes, this particular one was

not much different from all the past ones since we were feeling emotion-

ally and spiritually upbeat with the coming of warm weather. Our opti-

mism was never higher until it was abruptly interrupted by a mass of

people gathered around our favourite seal hunting camp when we ar-

rived there.

I parked my dog team a few hundred yards from the crowd and went

over to find out what the commotion was about. It was easy to recognize

the video cameramen, still photographers and reporters among the

crowd. They were jostling for position in search of catching the 15-second

video clip, the perfect photo image or some quotable words. There must

have been at least sixty media hounds, twenty dog teams and assorted

other hangers-ons milling around this blonde woman laying on the sea

ice, hugging a white-coated baby harp seal pup. I couldn't believe my eyes! What was the big deal?

"Who is she? Why the fuss over the baby seal?" I asked a man who was also observing the theatrics on the sea ice.

"She's the famously beautiful French actress, Brigitte Bardot. She's here to save the baby seals from the senseless slaughter they receive every spring from seal clubbers."

"I don't understand. What does she have against us? We're just simple Inuit trying to make ends meet by hunting and selling sealskins. It's our only bread and butter. Why is she targeting us?"

"I'm not exactly sure, but it may have something to do with her being an animal freak and feeling the need to identify herself as the saviour of all animal species on earth. Who knows, maybe it's just a publicity stunt. She hasn't exactly been seen on the silver screen lately."

"I'm wondering how she ever ended up fighting for the rights of baby harp seals. France has never even seen a single seal in its entire history... just curious."

"Well, by what was stated in the press release before all this happened, a self-proclaimed Swiss 'philanthropist' named Franz Weber sponsored this little tryst. He's also a bit of an animal freak. Rumour has it, there were supposed to be six hundred reporters who were to take this trip but there weren't enough dog teams in the world to take all of them here. Can you imagine six hundred reporters coming here on... ummm... two hundred dog teams? It would have been quite the scene."

"Have these French gone mad? Haven't they any notion of our lifestyle here?"

"I'd guess Brigitte had never heard of you guys until she was lured to come here. I'm sure there are a lot of mad French out there. And some are madder than others. I suppose one could observe that she is the maddest of them all."

After

Brigitte

Bardot

"I'd say she is. Did you notice something odd about that baby seal she's hugging?"

"Of course. It's stuffed."

"Some people! Some guts!"

"She certainly has the guts, but no discernible mind."

"Have you heard the latest blonde joke?"

"Uh-uh."

"How many blondes does it take to change a light bulb?"

"Dunno."

"One million. The first 999,999 blondes are such airheads they haven't a clue how screws work."

"You hit it right on the nail."

The photo-op was soon over. Brigitte Bardot put the stuffed seal into a gym bag and headed for the sledge she had taken to get here. All twenty dog teams soon sped away, led by Brigitte Bardot's team. It was at this point I promised myself I would never go see any of her B-movies ever again.

My family and I set up camp and were happy to be rid of the sixty reporters, twenty dog teams, Brigitte Bardot, et al. I was looking forward to hunting and gathering seals for their valuable skins, which we had come to depend on to make a little money to augment some lean times.

The spring and summer seal hunt was unusually bountiful. I kept thinking Brigitte Bardot may have brought us good luck by her now-infamous foray into our hunting and gathering culture.

When autumn came, I made my seasonal trip to the trading post to cash in my sealskins.

When I arrived with a sled-load of sealskins at the post, I was shocked to find out from the manager that the sealskin market had collapsed. The European Economic Community Parliament had voted to ban the entry of

<div style="text-align:right">

After

Brigitte

Bardot

</div>

all seal products destined for Europe. The trading post wasn't buying another dead skin from the likes of me or my fellow hunters. What a shock! What were my family and I to do without the much-needed extra cash?

I stood there in front of the manager, stunned, my mouth agape, at a loss for words!

"Here, take a look at this." The manager handed me a newspaper clipping.

'Bardot Succeeds in Ending Seal Hunt in Canada's Far North,' the heading screamed at my face. There she was, illustrating the story, hugging that damn stuffed seal!

"The bitch! How could she do this to us?!"

"Politics. The desire to be seen to be doing something without any relevance to either science or ecology. And for that matter, to the well-being of Inuit. There's a quotation in that story which I find quite amusing. She refers to the baby pup seals as 'little balls of wool.' Can you believe that?"

"I'm not the least surprised. What am I going to do with a sled-load of sealskins now?"

"Feed 'em to the dogs, I suppose."

I thought for a moment. I came up with a grand scheme to find out Brigitte Bardot's address and send the sled-load of sealskins. The manager agreed to help me send them off to her. If nothing else, that ought to rile her a little bit.

I went on to finish reading the newspaper story. Someone in the article was quoted as saying, "Until her arrival, the seal hunt story was all blood and death. But now it was blood and death and sex. No more potent combination could be put together."

The truth hurt bad in the guts.

If I had realized Brigitte Bardot was going to destroy the seal industry, I would have taken her for a long ride in my dog team that day and told her about the realities of our lives as hunters and gatherers. But I am not sure she would have comprehended what I would have told her. As a

After

Brigitte

Bardot

flesh eater, I probably would have riled her enough that she might have spat in my face. What can one say about radical animal-rights activists? They have dormant mindsets that can only see through the eyes of the animal beings.

When I returned to my camp later that day, I had a remarkable vision of a slightly senile Brigitte Bardot, an older and still unrepentant rebel, walking along a French street with an Inuk companion. I was amused to see that her upper body had turned into a harp seal!

This was actually a transformation she was to endure for a lifetime. She would completely turn into a harp seal when her human life was over. She had willed herself to be reincarnated as a harp seal! And, in true Christian tradition, she was wearing a cross around her neck.

Her Inuk companion seemed perfectly content to be with the aging Brigitte Bardot. He was about to get a rude surprise. A baby harp seal pup snuck up behind the two of them. He clubbed the Inuk's skull open! The blood and brain tissue spewed out on the street! Brigitte screamed her lungs out. She tried in vain to put the brain tissue, which was just a

pile of mush, back into her companion's skull. In a flash, the baby harp seal pup waddled behind a building and disappeared.

Later that day, I found out the truth of this horrendous act of violence. The ghosts of all baby harp seal pups that were ever clubbed to death over the years were now avenging atrocities done to them by humankind. The irony is, this was not happening anywhere else on Earth except in France.

It was now blood and death and sex.

After

Brigitte

Bardot

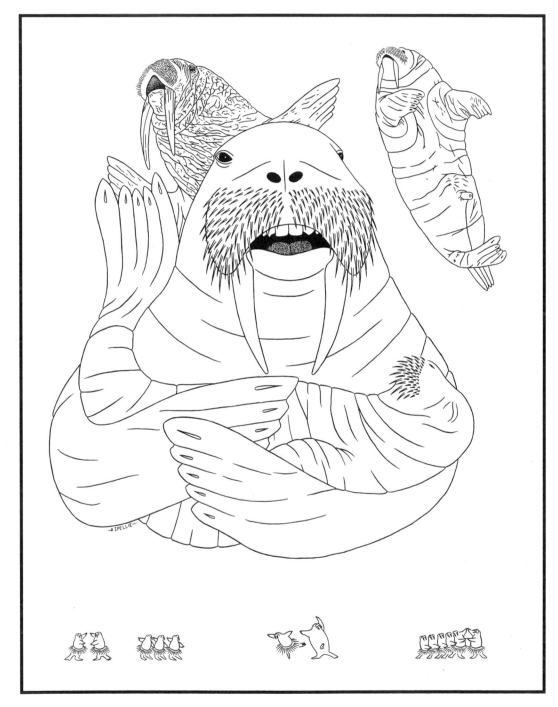

Walrus Ballet Stories

One year, our camp was unable to find walruses to hunt for a long time. Without the bountiful resources of these magnificent beasts, we were deprived of essential commodities like the tusks for harpoon heads, seal float plugs, meat for our families and dogs, blubber for our lamps, and skins for making rope.

So, at the beginning of the summer, I was able to visit a walrus herd after my spirit helper turned into an image of a walrus. It was on an islet situated in a beautiful cove somewhere in Siberia.

My objective was clear: to persuade some members of the herd to move to an area of the Arctic close to our camping grounds in Canada. And the only way I would be able to convince them was to make my spirit helper the strongest and largest bull with the longest ivory tusks they had ever seen in their lives.

When I arrived on the islet, I could see that plenty of calves had already been born. They lazed around nursing from their huge mothers and generally being squeezed between hundreds of adult walruses. A half

dozen or so bulls were fighting each other with their tusks, bellowing out angry noises on the higher ridges of the islet. They were obviously fighting for supremacy over all others in this particular herd.

When I first approached these bulls, a number of them knew they were no match for me and retreated without challenging me. But a couple of them were quite defiant and would not give up without a struggle.

I went at one of them as he reared up, raising his huge tusks to plunge them into me. He was only too happy to mutilate me if he could. I countered with mine, slashing the tips of my sharp tusks against the thick hide of my opponent. He was a furious bull with bloodshot eyes gawking at mine. He was not about to give up easily - a truly proud bull who had fought many a battle in his time. And so, for a few precarious moments, I thought I had met my match, strength for strength, tusks for tusks, tactics for tactics. But when I reared up and hammered one side of his neck with a near-fatal blow, he retreated into the sea and swam away.

The second bull was even bigger than the other, with tusks that seemed slightly bigger than mine, and fiercely sharp. I hesitated for a moment as

he lunged his bountiful girth at mine. I retreated slightly to escape his initial charge. What an angry bellow he gave out when he barely missed my neck. A gregarious beast who acted as if he was the superior bull. The rest of the herd watched in anticipation of his continuing reign after disposing of me. But I was not about to be humiliated by such a lumbering girth of a beast. I danced around every time he came forward, avoiding a direct hit from his huge, sharp tusks. Not surprisingly, the rest of the herd seemed to be cheering for my opponent since he was obviously the top bull in their herd hierarchy.

It seemed we were at loggerheads until I tried a tactical move I had learned in the Leningrad Ballet School. It was the effortless pirouette leap with the tusks turned to the right of my shoulder. I caught him completely by surprise, goring the back of his neck. He retired instantaneously, cried in great pain and lumbered off into the sea.

My surprise move turned heads in the herd. Now they knew who the new boss was. As I basked in the limelight, a female came forward, shaking her head in disbelief.

Walrus

Ballet

Stories

"I have never seen such precision in an altogether gracious tactical move against an opponent as potent as Aivialuk. Where did you learn such a mesmerizing move?"

Trying my best to look nonchalant after executing a well-practised manoeuvre, I started to explain:

"It was at the Leningrad Ballet School in 1955. The school had the most exemplary training discipline, the best ensemble and the most proficient, virtuoso dancers in the world. When one is in such company, one learned the craft quickly just to survive the school. There was never any room for slip-ups or carrying out your assigned duties half-heartedly. Otherwise, you were a perfect candidate to be given a pink slip and early retirement from dreaming about becoming the greatest ballet dancer in the history of walruskind. That is the short of it - not to bore you with my storied past."

"Allow me to introduce myself. I'm ballerina Dame Margot Fonteyn. Originally from Great Britain. Have you heard of the Royal Ballet?"

"Of course. In London. I danced with them a few times. That was one great city. A little dirty, but one hell of a place to perform. I could never get enough of the English aristocracy. Such pomp and circumstance. Such show of elegance whenever the members of the Royal Family attended our performances. I have great memories from those incredible days in the shadow of Big Ben."

"I was looking at you earlier as you fought with Aivialuk. I studied your features with the intensity of a curious prima ballerina. You looked very familiar to me. What, may I ask, is your name?"

"Rudolf Nureyev."

"**Giselle!**"

"Yes! 1962! I can't believe it! You are the same Dame Margot Fonteyn I performed with in **Giselle**! Please, please, forgive me for not recognizing you earlier. You must understand my mind was a little preoccupied during and after my determined struggle to defeat Aivialuk."

"I do understand. Your male egotism was at its very peak. Macho bulls utilize Machiavellian methods of gaining power. You two demonstrated exactly what mad bulls are made of. So, I do forgive you."

"Margot... give me a hug."

With some difficulty, and only by sucking in our considerable girth, Margot and I managed to hug each other. All was forgiven.

"I'm really surprised to see you here. What on earth are **you** doing here?" Rudolf asked Margot.

"Well, to make a long story short, I got fed up with unchecked capitalism and defected to Siberia. I am a much happier walrus living in an environment where there is no need to compete in societal cut-throat rat races that get you nowhere fast except an early visit to the hole in the ground. You know what I mean."

"Well... I suppose... in a way I do... if not blindly... "

"How's Mikhail Baryshnikov?"

"Oh, you mean that other Siberian defector? Oh, I try not to talk about him... really. Uhhh... something to do with, uhhh... professional jealousy, I suppose. But don't get me wrong, I respect him totally as a fellow walrus, and of course, as a fellow dancer. There's really no animosity between us, although I must say, there certainly are doubters out there. And, to tell you a little secret - and be shut-mouth about this - Margot, one of the reasons why I eventually won the battle against Aivialuk was because I pretended I was battling Mikhail. I mean, what can one do with a hetero-sexual?"

"Rudolf, you haven't changed a bit, have you? Neither have you changed your habits. I'm not surprised."

"I wouldn't change for all the money in the world. I **am** Rudolf Nureyev, for crying out loud!"

"I'm surprised to see you back in Siberia. I thought you had forsaken your motherland for freedom in the west."

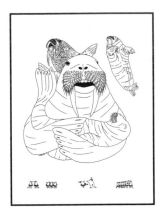

"Well, Margot, you know how time changes things for you. Yesterday is passé. This is now. I had my reasons for defecting. I fulfilled my dreams. I have other endeavours I still wish to accomplish. I came here with a mission."

"And what might that be, Rudolf?"

"I have come to assist any member of this herd who wishes to defect to the west. To freedom! Freedom from the clutches of communism! Freedom from thought control! Freedom from economic chaos! Will you assist me in accomplishing this?"

"I'll do what I can, Rudolf. I'll do what I can."

It took us five days, but we were able to convince close to five hundred members of the herd to make a run for it. Margot was incredible. I wouldn't have done it without her.

On a stormy night, as everyone slept, a herd of close to five hundred-strong, swam away to freedom. Destination: Baffin Land in Canada.

Margot decided she was perfectly happy to stay. She had married one of the greatest dance choreographers in all of Siberia and they had recently sired a future ballerina. I was indebted to her for the favour she had given me on this very important mission to bring back a much-needed walrus herd.

Needless to say, Aivialuk wasn't among those in the Exodus.

Walrus

Ballet

Stories

Arctic Dreams and Nightmares

The harsh realities of the Arctic world could stop your tracks in the snow and you wouldn't know what had happened to you. And this was the greatest fear we had as humans, just trying to survive for another day. We were human predators of wild animals that never wanted anything to do with us.

"Who are you humans to think you can interfere with our lives?" they asked themselves each day at the break of dawn. "Why were you put on the planet Earth in the first place? Your only purpose here is to kill us whenever you can. Who do you think you are?"

"I am man. You are animal. I shall eat you every day. This is how we humans evolve. To attain nourishment from the flesh of animals. To drink from nature. To pluck out the plants of the tundra.

"Nature has to have its victims. And it is not out of malice that we go out to torture all other living things walking in the vicinity of our birth places. It is only for the simple requirement that we have to eat you animals out

there. Please do not be offended by this dictum. It is the way it is. It is the law of nature. The law of predator and prey."

It was always in my sleep that I dared to dream the undreamable dream.

Dreaming of paradise. I always think it is just around the next mountain. I know it's there. That's why I dream of it. And I search for it each day and night. I know I will find it soon enough. Yes. Just around the next mountain. Paradise can be found there.

In paradise, we don't need to go out hunting. Struggling to survive is unheard of. The animals come to you whenever you need them. They come to sacrifice themselves. Kamikaze animals, them. Just like the divine wind, they come with opened arms.

Dreaming of paradise. We do it because we live on the edge of hell. Some days it is hell itself when an empty stomach beckons the bounty of paradise. These are the days we remember most as human beings. Because they make us think. Because they make us suffer. Because they make us cry. They touch our hearts in such unkind ways. What's a human being if he cannot and does not suffer?

Closing one's eyes just moments before going to sleep is a wondrous moment full of hope that tomorrow will bring bounty to your family. And then it will be paradise. That's what we live for.

But in the dead of winter, with the fierce wind wreaking havoc on your psyche, the closing of one's eyes before going to sleep for the night brings only fear. And it is at these times that one is easily drawn into nightmarish images inside one's imagination. Fearing fear. We draw conclusions even before losing ourselves in our sleep. We know our hearts will beat quicker than usual. And that is not healthy.

There are nights when a whiteout snowstorm leaves me immobile and I am stuck in my igloo for days on end. Some nights I begin to hallucinate in the netherworld of my madness. And there, in its midst, hell's creatures crawl over my soul. Drawing blood. Amputating my limbs. Sucking out my lifeblood. Hell has no friends in paradise.

In hell, they say being butchered alive is like having an orgasm. An ecstatic experience of abnormality. It leaves you eerily wanting more. Yes, let the butcher come around on his daily run. I shall make him happy. I want to have another orgasm.

Why is it the human mind cannot rest easy even as we try hard to make it rest as we sleep? Always, it is in vortex flux. No wonder we keep waking up dizzy. In a vortex, rest is not easy to come by.

It is this dizziness that we take into our waking hours. Never knowing whether or not we are really awake or still asleep. Thinking that we are actually awake when we are not. No wonder humanity has been, and is, such a failure on planet Earth. Perhaps humanity needs to be put on another planet, or better yet, in another universe. Now that would be cool.

Dreaming in the Arctic world is not quite like dreaming in other parts of the world. And so it is with nightmares. Perhaps there is something to be said about the mindset of individual cultures. We do have a different outlook on life, don't we? And this unique outlook has given us the experiences to dream unique dreams.

A world that encompasses no dreamers is a world of chaos. And so a human dreamer, as he dreams, lives a little more humanely. And had he not been able to dream, he would not be very different from a wild animal.

And so, it came to this one night as I slept alone in my igloo. I had an occasion to dream about paradise. Paradise, you see, is not at all like the biblical perception of paradise. It is not quite like the Garden of Eden. When one lives in the Arctic tundra, one is unlikely ever to see as much as a bush, but only low shrubs and tiny, intricate flowers in all the colors of the rainbow. This was a different sort of a paradise.

In my dream, I became the incredible shrinking man! I had inadvertently drunk water from a small lake which contained the ingredients that nature had mixed together over a millennium. Anyone who drank it shrank over the course of a year to a size too small for the human eye to see.

By the end of that year, I was living among the shrubs at the foot of a majestic mountain. It was as if I had been dropped in the middle of the Amazonian jungle! If one was looking for the largest trees in the world, one only had to come to the Arctic to see them. And if one was on the lookout for the largest blueberry bush, he was in the midst of my paradise.

I had become the only man in this particular paradise since no other human was ever to be seen again, although on occasion, I would hear thundering noises from afar. I always thought them to be my distant cousins who were walking about, perhaps looking for me. And even if they were able to find me, I could never relate to them again. A normal-sized human being could not communicate with insects underfoot.

This accidental drugging gave me extraordinary solitude I had been seeking for a lifetime. No other human would ever bother with me again, giving me rare solace from the chaos that humanity had brought to our world. I could live comfortably by becoming a vegetarian. At first this was a difficult transition after having grown up as a devout eater of raw flesh. Somehow, I felt at peace with myself since I would not have any trouble, ever again, relating to k.d. lang. I knew I could still inadvertently rile the Alberta cattlemen, but that was the least of my worries.

I was a world unto myself and lived happily ever after. This must be how the Christian god lives in His paradise, not in the far off Heaven, but between the shrubs underfoot in the middle of the Great White Arctic. I was convinced of this as I lived in my own paradise among the shrubs.

One night, during a particularly stormy week, I went to sleep with some apprehension in the back of my mind. I was getting worried about my family, whom I hadn't seen for close to a month, because of delays caused by the weather.

For me, it was a restless night of interrupted sleep. The whistling wind was driving me a little out of my skull. I drifted in and out of dreams that turned into nightmares. One of them I remember more vividly than the others.

As I lay there on the platform, I woke up with this huge eagle ripping out of my chest! My blood was splattering all over my face and body. Since the eagle began coming out from the right of my chest and ripped across to my left, my torso moved up and down accordingly. I had never felt so much pain in my life. The entire episode lasted at least three minutes and the eagle finally broke out of my body and flew away as if nothing had happened.

What a sight to suddenly see an eagle's head breaking out of my chest! I wondered for weeks what this nightmare meant. Finally, I was able to unravel bits and pieces of it and everything came together.

What the eagle represented was a caged bird that had been trapped inside my unconscious mind for a millennium. Apparently, in the beginning, it wasn't an eagle at all. It was a mere blood cell that had become extremely disenchanted living through the vessels of my body. It was a particularly intelligent cell that was able to convince or conjure other blood cells and various other cells inside my body to plan, over a long period of time, this spectacular escape. The planned escape was not unlike breaking out of Alcatraz.

The disenchanted cell became unhappy because my body had become unsafe to live in. Hardly any nutrients ever passed through the vessels except ravaging alcohol. The cell was absolutely tired of being drunk and was now extremely afraid of becoming an alcoholic.

It had taken all the cells close to twenty years before the final trillion or more cells came forward to complete a full-grown eagle! Then it was the matter of being patient and waiting for the right moment to finally make their escape.

It was at my most vulnerable, that restless night in the middle of a great storm, the vagabond cells made their move.

And once the eagle had broken free of my body, I became just another vegetating dead human being. Some of the most important cells that I needed to continue living had left me to perish!

This was an incarnation of a different eaglekind. Arctic dreams and night-mares - what a world unto itself!

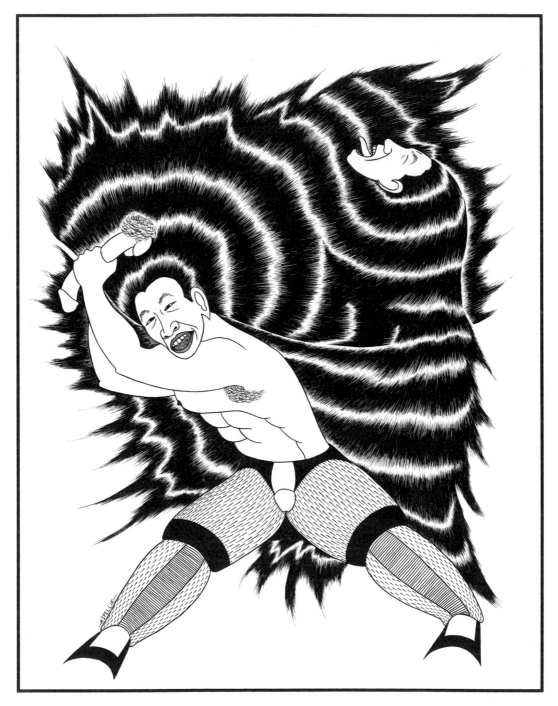

Love Triangle

In small, isolated camps, relationships between my fellow Inuit were sometimes precarious. For the most part, all of us tolerated our life-long relationships because it was the only way we could survive. And only out of necessity, did we go to extremes to solve disagreements and rifts between certain members of our camp.

For me as a shaman, one of my functions was to help sworn enemies reach reconciliation. Some of these conflicts sometimes reached crisis proportions which, unfortunately, I could not do anything about before fatalities occurred. But most times, I was successful in healing bruised egos and initiating the rebirth of cordiality between hearts and minds.

One summer, the weather was unusually hot, made hotter by an on-going feud between two men from our camp. One, named Ossuk, was a handsome young man who had recently moved in from another camp with his family. The other, Nalikkaaq, was an older man married to a beautiful woman, Aqaqa. Unbeknownst to Nalikkaaq, Ossuk had been having an affair with Aqaqa. It was by pure coincidence that Nalikkaaq found out about their amorous relationship.

One day, when Nalikkaaq was out on the sea on his qayaq hunting for seal, a snow bunting landed on the bow of his qayaq and started bantering on about Ossuk and Aqaqa. Nalikkaaq couldn't believe what he was hearing from the snow bunting.

Although the weather was perfect for seal hunting that day, Nalikkaaq could no more concentrate on the task at hand and kept missing seal after seal even at close range. Ossuk's face kept getting in the way of his number one priority and that was to bring back the much-needed seal to his family. He eventually lost all his patience and headed back to camp determined to get at the throat of Ossuk.

When he arrived at the camp, he went straight to his tent to confront his wife. Madness had taken hold of him and in his rage, he only grunted and mumbled unrecognizable words. Aqaqa could only shrug and continue her sewing.

"What is it you want to say?" Aqaqa asked Nalikkaaq. "Did you bring me seal?"

Nalikkaaq opened his mouth and tried once again but failed. He had to sit on the platform bed beside Aqaqa to calm down.

After a time, Nalikkaaq was calm enough to say the first words of inquiry into the alleged affair.

"Ossuk... " Nalikkaaq hesitated. "Ossuk... I hear, has been visiting your private parts. Is this true? Aqaqa, enlighten me, please!"

"Ossuk? Who is Ossuk? I have never heard of Ossuk. Who do you mean to speak of? Who is Ossuk?"

"I was out in the middle of the sea and this little snow bunting landed on my qayaq and told me the whole story about you and Ossuk. Don't try to deny anything with me, Aqaqa. I have heard it all... that you two have been entertaining each other for many days while I was out doing my husbandly chores to bring food to your side. Come on, Aqaqa, admit that you have betrayed me. Admit!"

"Nalikkaaq, Nalikkaaq... please give me the privilege of denying anything to do with Ossuk. Ossuk is a stranger in my life. I have never heard

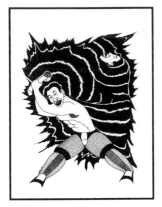

of Ossuk. I have never seen anyone by the name of Ossuk. Nalikkaaq, I plead with you to believe me when I say I have never had the privilege of being entertained by or to entertain a fictional man named Ossuk."

"But the snow bunting... is a messenger I have trusted for a lifetime. It knows what it speaks of. It spoke of amorous liaisons between the two of you. Don't deny this now, Aqaqa. Don't deny. Don't deny!"

"Nalikkaaq, I deny, I deny. And that is it."

Nalikkaaq decided to drop the inquiry for the moment. He had better things to do than to be stonewalled by his own wife about the rumour of her amorous interludes with Ossuk. He got up and went out of the tent. He looked down to the water's edge and spotted Ossuk preparing his qayaq to paddle out on a hunt. Nalikkaaq ran down to meet Ossuk. His curiosity was getting the better of him. He just had to get to the bottom of the wild rumour brought about by the snow bunting.

"Ossuk, are you about to go seal hunting?"

"Yes, Nalikkaaq. That is the purpose of my preparation."

"You mind if I join you? You see, I was out hunting earlier and did not bring back any seal for my wife and children. Maybe I will have better luck hunting with you."

"Fine. Suits me. One never knows when we might run into beluga whales. We must always be prepared for that."

In due time, Nalikkaaq and Ossuk paddled out together into the open sea. The wind was so calm, the sun bright with energy. A perfect day for hunting wild game.

They paddled for a long time until their camp was out of sight. Nalikkaaq raged secretly in his mind and heart. Somehow he kept everything to himself. But he knew he could explode any moment. The thought of Ossuk entering the private parts of his wife Aqaqa drove him on the brink of striking Ossuk in the back with the beluga whale harpoon. He was in a perfect position to do so, paddling slightly behind. He could do it at any moment, if he wanted to. However, he hesitated several times, knowing full well that one strike in the back would not guarantee a fatal blow. He was afraid that Ossuk would end up retaliating, and then he, Nalikkaaq, would be the one killed instead of Ossuk. The safer plan would be to wait

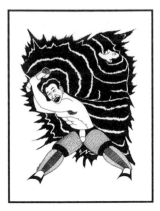

until they went ashore somewhere. He would then be more certain of killing Ossuk.

Nalikkaaq decided to concentrate on finding and hunting seals that were so urgently needed in camp. Killing a human could wait. It wasn't long before a seal popped up from under the surface of the water to breathe. Nalikkaaq and Ossuk paddled towards it, harpoons ready. In time, the seal popped up once again very close to their qayaqs. Nalikkaaq and Ossuk hurled their harpoons, both stabbing the seal at the same time. There was a minor dispute as to which of them had hit it first. In a situation like this, it was the custom to give the older man credit for the kill. Nalikkaaq smiled ear to ear. The seal was on its way to his wife and family. He was a happy man.

It wasn't long before another seal popped up and Nalikkaaq had thoughts of picking up the beluga whale harpoon instead of the seal harpoon. He was again imagining Ossuk embracing his beautiful wife Aqaqa, and, God forbid, in his own tent! The two of them paddled in the direction of the seal. Nalikkaaq had decided this was the moment he would make Ossuk pay for his dire deeds. He readied the beluga whale harpoon to be fatally plunged into the flesh of Ossuk. However, Ossuk was a very

perceptive young man. He noticed Nalikkaaq holding the beluga whale harpoon.

"Nalikkaaq, why are you using the beluga whale harpoon when there aren't any belugas around?"

"Ossuk, I just wanted to make sure the little seal died instantly with this larger harpoon. I have had experiences with seals escaping my seal harpoon because it wasn't powerful enough. This is the reason why."

"You know, as well as I, Nalikkaaq, that it is a bad omen to use a beluga whale harpoon on a seal. It will only bring you bad luck. You must respect the seal, and using the beluga whale harpoon means you do not respect it."

"You are so bloody right, Ossuk. I forgot. I wasn't thinking."

Nalikkaaq had no choice but to put away the beluga whale harpoon. He felt a little embarrassed by the young man since he was considered the elder and should, in the eyes of Ossuk, have known better. Nalikkaaq

quickly reverted back to his seal harpoon and paddled on. He felt incensed by Ossuk's very presence. He was boiling inside.

The seal popped up again to the right of Ossuk. Nalikkaaq could hardly see it. He went for it anyway as Ossuk easily plunged his harpoon into the hapless seal. Nalikkaaq's harpoon had misfired and strayed into Ossuk's qayaq, puncturing it. The hole was far enough from the water surface that it didn't spring a leak. Nalikkaaq's embarrassment turned into a feeling of humiliation. As he paddled close to Ossuk's qayaq to retrieve his harpoon, Nalikkaaq came up with an idea. The plan was to hit Ossuk's qayaq again, this time under the water surface so it would leak and drown this despicable adulterer.

"Please, Ossuk, forgive me for hitting your qayaq. The rope got tangled in my fingers as I released it. It was entirely an accident. I apologize."

"Accidents do happen, Nalikkaaq. Accidents do happen."

Ossuk pulled the seal onto his qayaq and prepared to paddle to the shore to butcher the seal. He was so hungry for it.

"Nalikkaaq, will you join me for a little feast on the shore?"

"I cannot refuse such an offer. I am famished for seal meat and blubber. And especially for warm blood."

Nalikkaaq was salivating as he paddled toward the land. The sinking and drowning of Ossuk would have to wait. Warm blood was all that was on his mind. Warm blood, not just of the seal, but also the warm blood flowing out of Ossuk's body.

It wasn't long before they landed on shore. Ossuk hauled his seal on top of a smooth rock. He began cutting the seal from just under its chin and down to its flippers as if he was unzipping it. The carcass steamed. Its blood was indeed still quite warm. Nalikkaaq crouched over the seal, cupped his palms and sunk them into the warm blood and sucked the blood with fervour.

"Such a heavenly drink!" Nalikkaaq celebrated, his lips coloured in crimson. "Nothing quite like it compares! Let me at its liver!"

Nalikkaaq retrieved his knife and cut out the liver. Then he cut off some blubber and ate it with the liver, mouthfuls at a time.

Nalikkaaq looked up toward the sky and put his arms up to acknowledge the Creator and said, "This is food for the gods. Thank you. Thank you. Thank you."

Ossuk wasn't saying much. He went about the business of filling himself. His appetite was fierce.

"What a blessed land we live in!" Nalikkaaq bellowed out. His voice echoed against the side of a mountain across the fiord. "It is at these moments we rejoice the bounty of this great land!"

"Indeed, Nalikkaaq, indeed," smiled Ossuk, gobbling seal flesh down his throat.

Nalikkaaq had forgotten about the rumour of Ossuk and Aqaqa's sexual trysts until the knife in his hand began reminding him of its uses other than cutting up seal meat. His vengeful self re-emerged from the depth of

his mind. 'I can end it all now,' he thought as he looked at Ossuk's busy throat.

Soon the little feast was over. Ossuk put holes alongside where he had slit the seal and closed the carcass by looping the holes with rope and put the seal back on his qayaq. Nalikkaaq cleaned his knife in the salt water and imagined it slicing up Ossuk. 'An adulterer deserves no dignity while alive,' he thought.

"Ossuk, did I tell you about the story of a bloody feud between two powerful shamans over the wife of one of the shamans?"

"No," Ossuk nodded.

"As the story was related to me some time ago, one of the shamans had committed adultery with the other shaman's wife and a bloody feud ensued for many hours in a camp. The camp members were given the most frightening show of their lives. It turned out that the two of them bared their chests and fought the wrestling match of their lives. The bloody feud ended when one of the shamans took hold of the adulterer's penis and swung him around in mid-air four or five times and, the poor

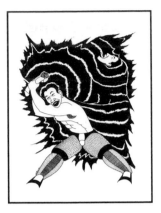

man, his penis and testicles were ripped right off his crotch! The penisless shaman managed to survive the ordeal but he was never to penetrate the private parts of a woman again, least of all, the winning shaman's wife. It was a horrendous spectacle, made more so when the shaman looked at the severed penis and testicles in his hand and then flung them violently out to sea. They floated off to kingdom come."

"Ouch," Ossuk cringed his face. "That's one of the most disgusting stories I've ever heard. Are you making it up?"

"Of course not. I think the adulterer got exactly what he deserved. Don't you think so?"

"According to the winning shaman, I suppose. What a way to be castrated. It hurts in the crotch just thinking about it. Would you have done that yourself if you found out that another man had been having an affair with your wife?"

"To give you an honest opinion, under the circumstance, I would probably do it."

"Gruesome... "

"Ossuk, can I ask you a personal question?"

"Yes, as long as it's within the bounds of decency, I will try to answer it."

"Have you ever committed adultery?"

"Never."

"Ossuk, that's a lie. Earlier today, I was visited by a little snow bunting who spilled out you and Aqaqa's best-kept secret. The snow bunting revealed to me that you two had been having secret liaisons. Isn't that right?"

"A little snow bunting?" Ossuk gave out a nervous laugh. "What a likely story. A pack of lies. Are you out of your mind, Nalikkaaq? It's a pack of incredible lies!"

"Don't deny, Ossuk. Don't you deny!"

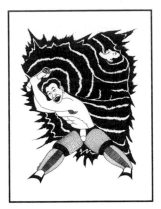

"Pack of lies! Pack of lies! Pack of lies!" Ossuk yelled at Nalikkaaq and started to push his qayaq into the water. He jumped into it and was soon racing toward the camp. He was determined to get away from his accuser as quickly as possible.

Nalikkaaq jumped into his qayaq and paddled after Ossuk. "So, Ossuk is paddling away from the truth!" He soon caught up to Ossuk. There they were, paddling side by side, one mouthing off vindictives, the other vehemently denying his accuser's words. The two men seemed like they were in an Olympic qayaq race as they skimmed at great speed through the calm sea.

"You'll pay for this!" Nalikkaaq yelled at Ossuk. They were nearing their camp. The people in camp heard and saw what was happening and watched the two qayaqers coming to land on the shore. They went down to find out what the commotion was all about.

Ossuk and Nalikkaaq simultaneously jumped out of their qayaqs. Nalikkaaq immediately went over to confront Ossuk. "You are a dirty little adulterer!" Nalikkaaq yelled pointing an index finger at Ossuk. "Let

everyone know this dirty little truth! Ossuk, you cannot deny it anymore!"

The people were a little shocked that something like this was taking place right in front of their faces. They looked at each other in utter amazement. Nalikkaaq was pushing Ossuk's chest and shoulders. "Dirt!" he yelled. "Dirt!"

I walked over to the two feuding men and told them to calm down. "You are men who are capable of reasoning with each other and a fight like this will not solve any of your troubles. So, I suggest a wrestling match between the two of you. Right here and now."

"Fair enough," Nalikkaaq immediately agreed.

However, Ossuk was hesitant. "I am an innocent man facing a false accusation of committing adultery with Aqaqa! I will not submit to such false pressure! Nalikkaaq, take your unfounded accusations and anger elsewhere!"

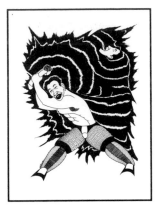

"Wait! Wait! Wait!" Aqaqa came running down to the shore from her tent. Everyone looked around to see a frantic Aqaqa with her sewing still in hand. "I have a confession to make!" Aqaqa stopped and caught up with her breath. "Nalikkaaq, the amorous rendezvous between me and Ossuk did happen. I have fallen in love with the man of my dreams." Aqaqa turned to her lover. "Ossuk, do not deny it anymore. Let the truth be known. Confess! Confess! Confess!"

Ossuk was in a state of shock, mouth agape. "What are you saying, Aqaqa? What are you saying?"

"Let the truth be known, and I have said it."

Ossuk wasn't going to admit to anything, but everyone now knew the truth. Nalikkaaq could hardly contain his anger. "Enough!" he yelled and lunged at Ossuk.

"Nooo!" I yelled at Nalikkaaq and went between the two men. "Reason shall prevail. A wrestling match is in order. It is our ancient method of solving disputes and depressurizing a raging mind. Nalikkaaq and Ossuk, bare your chests."

"So be it," Ossuk succumbed to the pressure. At any rate, he would not back down from a challenge. He had the advantage of being younger and stronger than Nalikkaaq. He would rely on those qualities, if he could, to defeat Nalikkaaq.

The Arctic Wrestling Federation Championship Match was on. The women cried out of fear. The children held onto their mothers and shuffled their feet on the ground. The men yelled in excitement.

Nalikkaaq and Ossuk were almost a perfect match at the beginning. They would take turns lifting and slamming each other on the ground, to thunderous applause mostly from the men, cries of fear from the women, to wondrous curiosity from the children.

At one point, Nalikkaaq went after Ossuk's throat and almost choked him to death until Ossuk was able to knee Nalikkaaq in the crotch and release his hands just in time. There was a short pause in the struggle as Nalikkaaq clutched his crotch with both hands and Ossuk coughed out the effects of his near-choking.

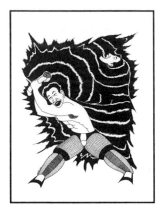

"Come on, you wretched men!" A man yelled out from the crowd. "We're not here to watch a bore-off! Get on with it!"

Aqaqa was unusually calm about what was happening in front of her. Perhaps it had something to do with her confidence in Ossuk, her lover, that his youth and strength would eventually prevail over the aging body of her husband, Nalikkaaq.

Aqaqa underestimated one thing, her husband's experience and maturity. Nalikkaaq was deft at checks and balances, leverages and angles that one acquired only with experience. He had practised wrestling holds for years and was exceptionally good at deception. He had plenty of moves that mesmerized the lesser-experienced Ossuk.

"No! No! No!" Aqaqa yelled as Nalikkaaq suddenly got hold of Ossuk's penis and began swinging him around in mid-air. "No! No! No!" She yelled again.

"Aaaahhhh!" cried Ossuk as Nalikkaaq threw him to the ground, minus his penis and testicles! Then Nalikkaaq looked at the severed parts and threw them out to sea, bellowing out obscenities.

Aqaqa became hysterical, crying on her knees looking over Ossuk.

What Nalikkaaq hadn't told Ossuk earlier was that he was the shaman who had ripped off the penis of the other shaman! Now he had done it again, this time to the hapless Ossuk.

In Nalikkaaq's world, three's a crowd.

Love Triangle

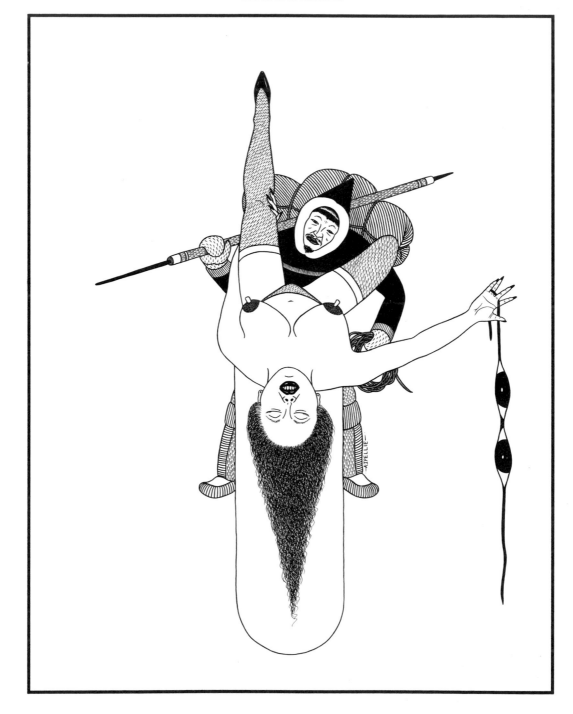

Hunting For Skins and Fur

Travelling through time and space gave me the opportunity to explore worlds beyond the confines of our small camp. It was quite by accident that I ran into a group of Inuit who had very different customs than ours.

They were also hunters and gatherers like us. However, it was a great shock to find out they hunted, not wild animals like seals and walruses, but common exotic dancers from other cultures! I thought I had gone on a loop when I found out about this incredible truth for the first time. It was hard to comprehend a society that condoned the hunting of exotic dancers but there they were, roaming the tundra, sea and ice, looking out for tenderloins.

I had an occasion to come down to Earth to enquire further about this truly exotic phenomenon. I met a lone hunter walking on the sea ice by the name of Romeo. Romeo was a man of about fifty. He was unusually well-groomed and had slapped on an irresistible dab of top-of-the-line cologne made in Germany. He didn't look much different than any ordinary hunter but he walked with a certain swaggle of the hips. I couldn't help but to burst out with laughter when I first met Romeo.

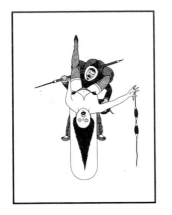

"Has this world gone a little mad, Romeo?" I asked, with a wink of an eye.

"Perhaps to outsiders like you. This is a part of our old tradition which is integral to our daily lives. It's a part of our sacred rituals that is as old as man himself."

"Tell me, Romeo. What on earth do you do with an exotic dancer when you hunt one down?"

"First things first, as is the custom. They do an exotic dance usually on a cylindrical podium which immediately arouses our libido to the point of penetrating them on the spot. It's a ritualistic act that gives us the stimulus to dream of exotic locales full of sensual tenderloins gyrating to the sounds of alto saxophone in the middle of nowhere. And it is only after we have ejaculated inside them that we are able to obtain their trust as worthy connoisseurs of landlocked exotic dancers. It is quite an unusual ritual as you can well imagine."

"Well, Romeo, I am little numbed by what you have confessed. Are you married? And what does your wife think of all this?"

"I am a happily married man. Have been for thirty-five years. The thing is, none of our wives know anything about these exotic dancers. Everything that happens between me and the dancer is strictly confidential. That's why I am a happily married man."

"So, Romeo, what happens after you've completed the ritualistic act?"

"Something quite amazing happens. The exotic dancer is so full of ecstasy that it shrivels up and disintegrates into dust. That is why there is never any trace of them when I am travelling with my wife and family. It's a male gender exclusive club that no others will ever know about. So, as you would imagine, there are many hunters like me who'd much rather travel alone because that is the only time the exotic dancers make an appearance."

"Romeo? How did this incredible ritual ever come about?"

"Long, long, time ago, a great catastrophe occurred in these parts. By the cruelty of nature, all the females were strickened with a diabolical disease that was to obliterate them from the face of the Earth. This meant all the

Hunting For

Skins and Fur

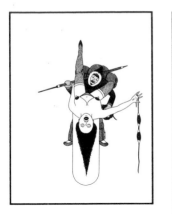

men were left without any females which, in turn, doomed our society unable to reproduce. It was only by sheer luck that a great shaman was able to make a spirit journey in search of any females that may still be left on planet Earth. As it turned out, the only ones left were these exotic dancers plying their trade on a gypsy caravan. As one would imagine, the great shaman was quite the charmer. He charmed a caravan full of exotic dancers to make the rounds of our stricken land.

"It took some years, but the exotic dancers had done their duty to replenish the population with newborn females. And as an act of gratitude, the great shaman was able to convince many of the dancers to make yearly rounds as spirit beings which served the purpose of entertaining hunters like me who were an integral part of a great revival to repopulate our people.

"It is by the virtue of magical trickery that the exotic dancers are able to appear on the path of a hunter who has come a-calling. The ritualistic act is a sacred act of revivalism among our population and ensures that our

females will remain fruitful and never again threaten our extinction as a unique people."

"Romeo, that is some wild story. Who among us would have thought of such an incredible story? Tell me, will you ever again go without the services of these exotic dancers?"

"Not likely. They have become to us men as necessary as breathing air, eating food and drinking water. That's why we consider it a sacred ritualistic act. It's probably here forever."

"Romeo, thanks for imparting this. It's a shocker to me. Good hunting to you."

"My pleasure. And to you, too."

I waved good-bye to Romeo, who gave me a mischievous wink of an eye. He was off again hunting for skins and fur.

<div style="text-align: right">Hunting For
Skins and Fur</div>

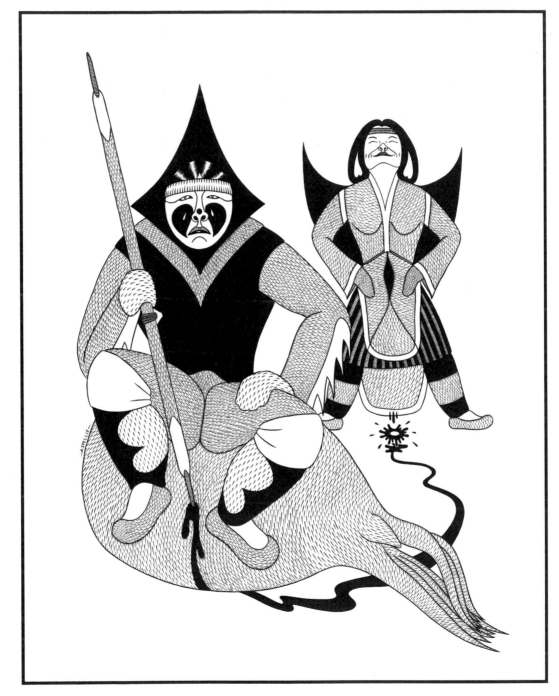

The Agony and the Ecstasy

When young Prince Char was born, he was reluctant to come into the world since he wasn't sure whether or not he would turn out to be fit for a King. His mother, Queen Elisapee, ended having a long, hard labour, when she should have had an easy one.

His father, Prince Pilipoosee, was only too happy to have a first son. He didn't care that his wife went through such a long, painful labour to squire Prince Char. He was just glad that one day a real man would again take over the throne from a woman. He hopped along the tundra in joy when he heard news of Prince Char's birth and handed out Cuban cigars to his buddies around the Royal circuit.

From the beginning, young Prince Char always conducted himself with a bit of pompousness. "How fortunate of me to have been born into a monarchy," he would announce to his peers, his pinky raised in the air. This often aroused curiosity about his sexuality. Was he born gay? Did he have homosexual tendencies?

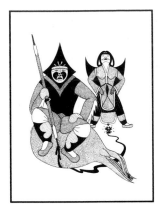

Over time, there were telltale signs that the rumours could turn out to be true. For instance, whenever his father, Prince Pilipoosee, took him hunting for wild animals out on the vast Arctic land, he always regretted having to hunt at all. He complained that he didn't enjoy being a hunter and would much rather be a homemaker. This bothered Prince Pilipoosee to the point of pushing him harder to learn about the manly chores of a future great hunter and gatherer.

"Now, now, Prince Char, don't lock your knees together when you are about to harpoon a seal. Spread your feet wide to maximize the force of the harpoon you will plunge into the seal. And, your pinky should be holding the harpoon along with the other fingers and thumb. Don't ever forget that. It's very important."

Poor Prince Pilipoosee. He could never get the message across to his first son. The days out on the land were total failures. He would give up in frustration and head back to camp. However, there was always the next day. There was still some hope, after all, Prince Char was still an adolescent.

One day, his mother, Queen Elisapee, caught Prince Char wearing one of her dresses. "Not nice, Char, please undo it and go out and play with your buddies."

Prince Char would let out cries of protest. "But, mother, I love to dress up for the boys. Please let me dress up."

"Char, out!"

"I am a future King, mother. You ought to have some respect for my wishes."

"Out! Char! Now!"

He would eventually go out among his male friends, promenading back and forth, pinky in the air.

Queen Elisapee and Prince Pilipoosee began talking about the behavioral patterns of Prince Char. They were greatly concerned that the future King could turn out to be a pansy. At least that's the message they were receiving from the daily mannerisms of Char.

The Agony and the Ecstasy

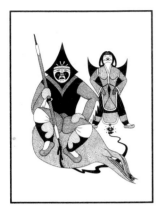

One day, out of the blue, Queen Elisapee and Prince Pilipoosee, both unusually stressed out, called on me for advice. So I immediately headed to their huge snow and ice palace situated on a spectacular fiord.

"It's Prince Char," Queen Elisapee began with down-turned eyebrows shortly after I arrived. "My husband and I suspect we may have sired a pansy. We are afraid our subjects will reject the entire Royal Family if they ever find out that their future King is really, uhh, quite gay. What do you suggest we do about this hypothesis?"

"The smart thing to do would be to wait until Prince Char's puberty. Then you can be absolutely sure whether or not he is really a pansy. There is no need to panic about this now. It would be a mistake for you to come to a conclusion since adolescence is always so unpredictable in character-izing the true leanings of such innocent minds. When is Prince Char reaching puberty anyway?"

"My God, in less than a year!" Queen Elisapee cried out. Prince Pilipoosee shook his head.

"As I said, let things happen and see what becomes of Prince Char."

"Thanks for the advice. We shall wait patiently with a certain amount of nervous anticipation," Prince Pilipoosee said as he showed me the door. Queen Elisapee hung her head down.

One fine day, Prince Pilipoosee took his only son out on another seal hunting trip. It was time for him to get his first seal. He had high hopes for the young man. It wasn't long before they spotted a breathing hole. As he had done on previous hunting trips, Prince Pilipoosee instructed his son exactly how to harpoon the seal.

Prince Char still had a lot of difficulty with the stance. In the beginning he would have his feet wide apart, as was customary, but then he would become quite self-conscious and put his knees back together again, to the great dismay of Prince Pilipoosee. And that pinky! It just couldn't get enough attention, even out in the middle of nowhere.

After telling Prince Char to be on the lookout for any movement of water in the breathing hole, he went on with the task of walking around in wide circles on the ice, trying to force the seals to the breathing hole where his son was waiting.

Prince Char began yawning after a couple of hours. He was about to doze off when the water below him finally started to move. Something was afoot. He took the harpoon and managed to remember to spread his feet wide and the pinky was firmly gripping the harpoon. He plunged the harpoon into the water just as he saw the snout of the seal surface to breath. He had caught his first seal! He immediately yelled to Prince Pilipoosee to come and help him haul in the catch.

"Char, hold on!" Prince Pilipoosee was so excited that he ended up slipping twice and falling face down on the melting sea ice as he ran toward his son. "I'm coming! Steady now! Steady!"

There they were, father and son, struggling to pull in the huge seal from its breathing hole. It took them quite a long time until the seal died and floated in the water by itself. Prince Pilipoosee went to get his dog team to help pull the seal out of the water. In due time, the huge seal was on top of the ice.

"Char, you've done it! I'm so proud of you! You are now a man!" Prince Pilipoosee couldn't contain his pleasurable excitement at such a momentous occasion.

"Father, please refrain from calling me a man. It doesn't seem appropriate. I don't exactly feel like a man. I'd rather be sitting at home than be here acting like a man. It hurts to be doing manly things. I was born to be a homebody. Please understand, father."

"But, Char, you are a man! Only a man could kill a seal as huge as this! You are a man!"

When father and son got back to camp, Queen Elisapee was ecstatic about her son's first seal. "Our son has become a man!" she exclaimed to everyone around. "He is a man!"

Prince Char, meanwhile, was suffering a private agony. He suddenly stabbed the seal in frustration with the harpoon and sat on it. Tears were trickling down his cheeks. The seal's blood flowed out to the ground from pressure caused by Prince Char's weight. It joined the blood coming out of Queen Elisapee's crotch. It was an odd scene. But what did it all mean?

Queen Elisapee was in such an ecstatic state of mind that she was unable to control her blood flow. The unity of her blood and the seal's blood

amounted to the unison of agony of the seal and the ecstasy of Queen Elisapee. And caught in the middle was Prince Char, who had been born a male when he should really have been born a female. Being called a man gave him a feeling of betrayal by the very people who gave him birth. There lay the agony of his life, and the ecstasy in his parents, for having been born a male.

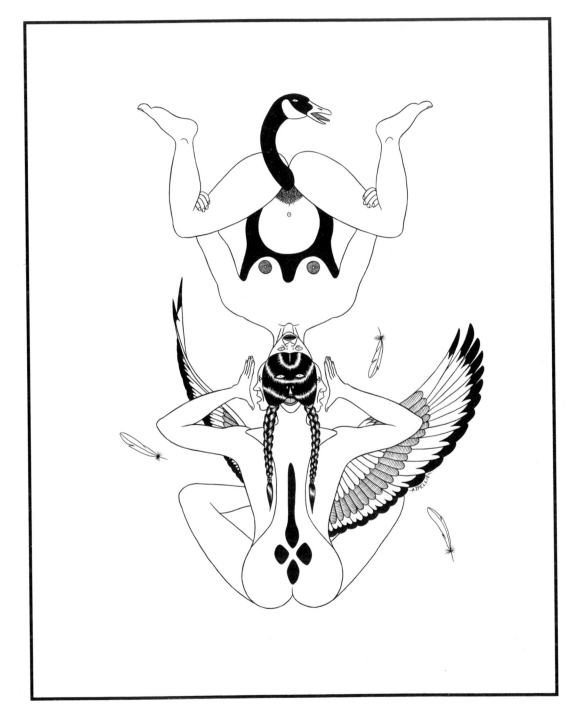

The Woman Who Married a Goose

In an Arctic world where desperation drove both humans and animals to extremes, I was always prepared to run into some gruesome act that was being committed or had recently been acted out. But sometimes, an event out of circumstance chased the wits out of my mind. This event was such a time.

It was early spring when my family and I travelled to a favourite goose-hunting and egg-picking area. This was usually a special time when we could pick fresh goose eggs for the first time in a year. They were a delicacy since they were so rare.

Each member of our family usually chose a predetermined area that they would each cover. So I chose mine, which was a little off the beaten track thinking it would be a logical place for a flock to nest in peace.

When I arrived there, I was totally taken aback by a naked woman whom I had never met before seemingly struggling with a goose. I kept myself low on the ground and observed what was happening in front of me. It

seemed the woman was having a hell of a time killing the much smaller and weaker goose, if indeed that's what she was trying to do. That's the first impression I got when I came upon them.

I must have laid there on my stomach for close to half an hour when the woman began making noises which were completely out of the ordinary under the circumstances. It sounded as though she was having an orgasm! At least that's how I made it out to be since I had often heard the same sounds coming from my own wife when we made love. Suddenly the goose sounded as though it was making the same noises I make when I have an orgasm! Unbelievably, I was witnessing a mating ritual between the woman and a goose!

After a time, the goose flew off and the woman put her clothes back on. I got up and walked in her direction, pretending that I hadn't witnessed the mating ritual. She saw me coming and tried to avoid making eye contact. I walked over to meet her. At first she didn't want anything to do with me and avoided speaking to me. It was only after I explained who I was that she was able to feel more relaxed. I could understand that making love to a goose would make one a little perplexed, but I could also

understand that she would still be a little buzzed from just having had quite the orgasm.

I was able to coax her into explaining who she was and where she came from. Apparently, she had become a social cast-off from her camp, disowned even by her own family. She had been relegated to living by herself some distance from the camp. She was now in her middle age, often having to hunt and gather her own source of food.

In time, she had become so lonely for a man that she almost went crazy one day. She had gone for a long walk one spring day and screamed her lungs out of frustration and remorse. She had happened upon a geese colony which had settled on the very land we were standing on.

As luck would have it, a male goose had noticed what was happening and walked over to this woman named Oiqangi and started talking to her. Oiqangi was greatly surprised that a goose could even talk Inuktitut. It so happened that, as the goose had related to her, he was also a cast off from the flock and that he had lived a similar life as Oiqangi. His name was Nuliaqangi.

The Woman Who Married a Goose

Over time, the two had become great friends. It got to the point where they became quite intimate and were soon constant lovers. The only problem was that the goose had to leave every autumn in order to survive. So as it turned out, this particular day was their reunion after Nuliaqangi had arrived back from the south with the flock.

It was a little surreal listening to Oiqangi, but it made perfect sense that they would have gotten together and married under the circumstances. I was also surprised to learn that Oiqangi gave birth to five or six chicks every spring after they had mated, just like all the other geese in the flock.

It turned out that the arrangement was perfectly good for both of them but, for Oiqangi, the winters were lonely times for her when Nuliaqangi was away. But it was better than having no one to love you at all.

That was the incredible story of Oiqangi, the woman who married a goose called Nuliaqangi.

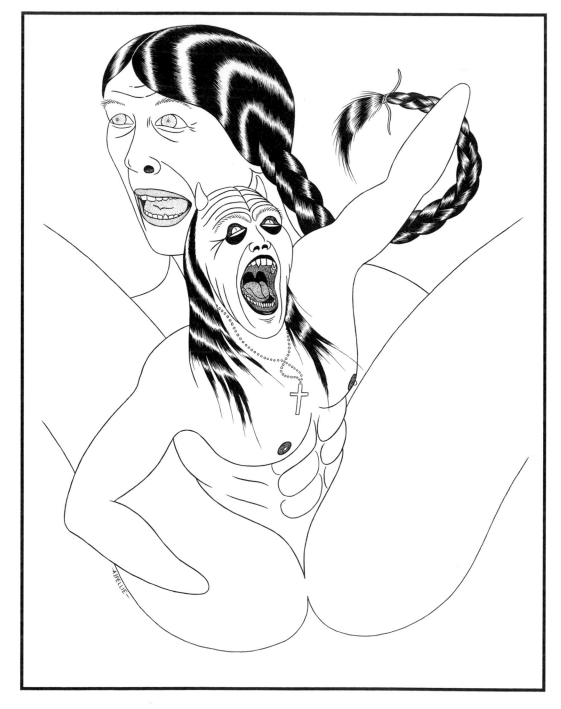

The Exorcism

One of the most frightening experiences I've ever had as a powerful shaman was the longest ten days I've spent in my entire life.

I was called upon by a family in distress. It was in a camp that had been possessed by the demon of a recently deceased shaman who had practised his trade more as an evil shaman than a good shaman. As it was told to me by Kappia, the man who had called upon me, the evil shaman by the name of Guti, which meant God, had cast his evil spell on this man's family of ten. It turned out that Guti had many run ins with Kappia. These had started out when a struggle between them over the leadership of the camp came to a head.

Shaman Guti had abused much of his powers to gain material things for himself. Not only that, there were many nights when he would sexually abuse the women and some adolescent girls in return for his shamanic services, which were usually total failures. And those were the main contentions of Kappia about Shaman Guti's leadership, or lack thereof.

One night, during a furious snowstorm in the middle of winter, there was a great struggle between Kappia and Shaman Guti. It was by sheer luck that Kappia was able to get an upper hand since he had wounded Shaman Guti earlier in the abdomen with his knife. It was the combination of the long struggle and the spilling of great amount of blood that eventually befell Shaman Guti.

"I put a curse on you and your family which will bring eternal punishment on all of you!" These were Shaman Guti's last words as he lay on his stomach. He had stared stone cold with bloodshot eyes into the eyes of Kappia and they remained opened as he passed away. The colour of his brown eyes turned white as his life became dormant forever.

Kappia had a sensational revelation through his body that spoke volumes about how relieved he really was. To realize that the despicable tongue of Shaman Guti would never again utter another abusive word, and that his physical body would never again touch a female or a young girl, and that the camp would never again be misled.

There wasn't a single remorseful soul in camp to see Shaman Guti finally gone. In fact there was only a huge celebration for the demise and fall of a hated man. The fear in people had finally left.

However, the jubilant expression soon turned into bitterness when the curse of Shaman Guti's last words were realized. Kappia and his family would suffer most as Shaman Guti had predicted. And this was when I came into the picture.

The task at hand was fraught with danger for the simple reason that Shaman Guti's demons would have to be aroused again for the purpose of exorcising them from Kappia and his family. For ten days, none of us slept since the exorcisms needed to be done non-stop twenty-four hours a day. Each member of Kappia's family had been affected in different ways by Shaman Guti's curse. There were many nights when one or two of them and sometimes all at once had horrific nightmares. And more often than not, most of them would come out with terrible fevers and it was not unusual to witness members vomiting their food several times each day. There were many sleepless nights as the camp members would hear one or two of Kappia's children screaming their lungs off for hours on end.

The Exorcism

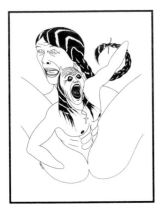

The demons of Shaman Guti were playing havoc with Kappia and his family.

Finally, after ten long days, I was able to do the last of the exorcisms and it was on Kappia's wife. She had to be the last one exorcised since she was the mother who had sired all of the children and that by doing the last exorcism on her, the demons of Shaman Guti would never again impregnate any of the victims.

The surest and the most effective way to exorcise Shaman Guti's demon from Kappia's wife was to remove all her clothes so that the demon would have nothing to cling onto when it was being pulled out. Then there was the plan to remove the demon's hands in order to prevent it from gripping onto the insides of Kappia's wife. After I was sure the hands were gone, I went for the final push.

The first thing I saw were the horns of the demon as its head began to come out of Kappia's wife's vagina in the manner of an infant being born! As the head came out it was hissing like a snake with its mouth wide

The Exorcism

open. I was surprised to learn that the demon was wearing a chained cross around its neck.

Kappia's wife screamed with the kind of pain she had never felt before. The excruciating pain didn't even compare to pains of childbirth.

Shaman Guti's last demon was finally exorcised from Kappia's family.

It was with great relief on the part of all of us involved in this ten-day ritual that we were able to relax and get some well-deserved rest and sleep.

The chained cross, as it turned out, was Shaman Guti's last straw in trying to prevent his only remaining demon from being exorcised from within Kappia's wife. After all, Shaman Guti's name meant "God".

GLOSSARY OF INUKTITUT WORDS AND THEIR MEANINGS:

Story Three: Nanuq, the White Ghost Repents

Nanuq:	Polar Bear
Nuna:	Land

Story Four: I, Crucified

Tusujuarluk:	Envious

Story Five: Public Execution of the Hermaphrodite Shaman

Ukjuarluk:	Big Bearded Seal
Piu:	Pretty

Story Nine: Trying to Get to Heaven

Shaman Qilaliaq:	Shaman "Going to Heaven"
Tootkeetooq:	Stupid

Story Fourteen: Walrus Ballet Stories

Aivialuk:	Big Walrus

Story Sixteen: Love Triangle

Ossuk:	Penis
Nalikkaaq:	Crotch
Aqaqa:	Vagina
Qayaq:	Kayak

Glossary of Inuktitut Words and their Meanings, cont'd

Story Nineteen: The Woman Who Married a Goose

Oiqangi: Without a husband
Nuliaqangi: Without a wife

Story Twenty: The Exorcism

Kappia: Scared